FADING ADS OF
CHICAGO

FADING ADS OF

CHICAGO

JOSEPH MARLIN

THE
History
PRESS

Published by The History Press
Charleston, SC
www.historypress.com

First published 2019

ISBN 9781540238863

Library of Congress Control Number: 2019932634

Notice: The information in this book is true and complete to the best
of our knowledge. It is offered without guarantee on the part of
the author or The History Press. The author and The History Press
disclaim all liability in connection with the use of this book.

DEDICATION

To my brother Jerry, who encouraged me to publish my fading ads pictures; my son Jeff, who located fading ads on the North Side; and my wife, Shirley, who supported my interests and was uncomplaining about my excursions to find another fading ad. Sadly, none lived to see this project to fruition. And thanks to Marilyn, who more recently accompanied me on jaunts to further my search.

CONTENTS

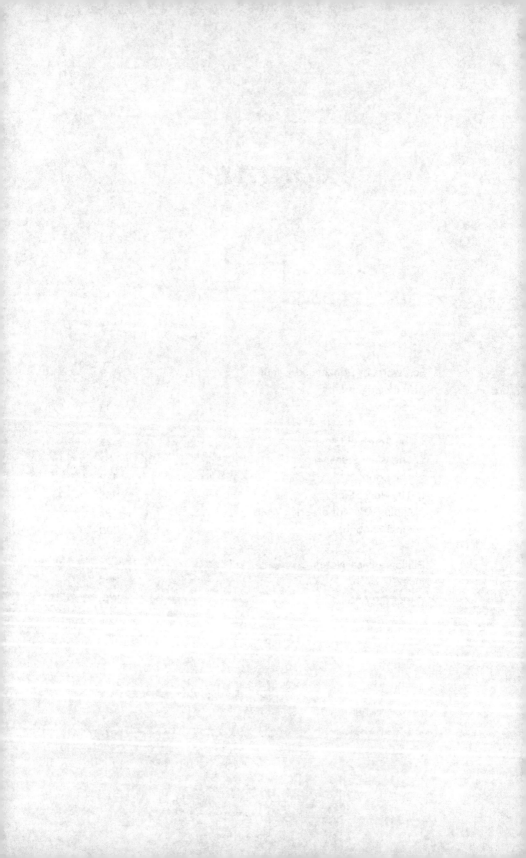

FOREWORD

As the author of this book warns, hunting fragments of fading ads while driving a car is a dangerous sport. How many times during my own expeditions have I spotted a sign, shifted lanes and slammed on the brakes without really looking? Too many! At this point, I won't take along a passenger. I fear for their safety and am too startled by their "Watch outs!"

I say this to set a context for the fading ads in this marvelous book. The building-sized block-letter promotions for Coca-Cola, Gold Medal Flour, Bull Durham Tobacco and even, ironically, Nash and Cadillac automobiles, were never meant for distractible drivers. They were meant mostly for urban pedestrians, riverboat travelers, streetcar riders and train passengers. In fact, the interlocking rail, river and canal networks along which these signs were placed are the very reason the products they promote exist. As mobility increased, travelers unfamiliar with local products found in the promises of quality, uniformity and safety offered by national brands a balm of reassurance and stability.

In a roughly twenty-five-year period between 1890 and 1915, and then trailing off for a few decades after, agents working on behalf of syrup producers in Atlanta, tobacco farmers in North Carolina and mill owners in Minneapolis made deals with individual building owners in business districts across the country to plaster their public-facing walls with advertisements that, though hand-painted, followed corporate-approved standards for logo, fonts and colors. Unconstrained by ordinances that would later limit outdoor advertising, tens of thousands of signs were painted.

Today, after virtually all newspaper and magazine ads have decayed to dust, and after millions of TV and radio spots (not saved to YouTube) have dissipated into so much cosmic radiation, thousands of ghost signs still haunt our landscape.

FOREWORD

This book is a treasure. Its images were captured in the 1980s and '90s, decades before interest in this topic grew hot. Many of the signs presented here have succumbed to the bulldozer. But some can still be found haunting downtown alleyways, abandoned buildings and old warehouse districts. They are messengers from the dawn of our modern media-saturated world. And each has quite a story to tell.

—Ronald Ladouceur
Principal and founder of POSTMKTG
and professor at the University at Albany

ACKNOWLEDGEMENTS

S everal persons have helped me in important and different ways and to them I owe a debt that I cannot really repay. It's wonderful to know people who have knowledge and skills one does not have and who were willing to use them to help this book come to fruition. I thank the following:

Fred Stein is a retired commercial and newspaper photographer who scanned all the photographs and offered useful advice along the way. He graciously volunteered his time, his energy and his eagle eye for this task.

Ilene Shapera Fenton is a retired editor for major book publishers. She used her extensive knowledge and experience to improve the text by making it conform to current publishing standards. And she asked questions that helped me clarify some of my thoughts and statements.

Ron Ladouceur is the principal and founder of POSTMKTG and a professor at the University of Albany. I much appreciate his brief but pithy statement that is the foreword for this book.

Carla Spann is my computer guru who formatted the text and rescued me from various computer miscues. She also helped do an initial edit.

Bill Dolnick is a retired school social worker with an interest in fading ads. He drove me to the site of many of the ads in this book to see if they were still there. Many of the entries in the captions under the pictures relating to whether the ad is still visible are the results of his efforts.

Shelby Stone is an artist who helped locate negatives for scanning.

Ben Gibson is the acquisitions editor for The History Press who initially encouraged me to propose this project to The History Press and provided information and support as needed. And my thanks go to The History Press for

ACKNOWLEDGEMENTS

deciding that this book was appropriate for its publishing needs, and to Abigail Fleming, production editor with The History Press, for her constructive comments and editorial improvements.

INTRODUCTION

WHY THIS BOOK?

This is the first book of its kind about fading outdoor advertisements found on buildings and other structures throughout the city of Chicago. The majority of the ads assembled in this volume were discovered painted on the brick side walls of buildings, although a few, in chapter 5, were painted on other surfaces. I took most of these photographs in the 1980s and 1990s, although some were taken this century, as late as 2018. I am an amateur photographer using amateur equipment. Approximately 80 percent of the images were originally 35mm color slides or prints from 35mm color negative film. All 35mm pictures were taken using an old standby for amateurs—the Canon AE1. The remaining pictures were taken using a Canon point-and-shoot camera.

My initial purpose in capturing these images was to document fading ads merely because I found them interesting. I cannot recall having thought I had better do this before they disappear. I had no idea they might someday be published, almost forty years from the day I took my first picture. Occasionally, I would do a slide show (remember those?) for a group of interested folks who had learned about what I was doing. This project lay almost fallow for years. It was only when I visited the Sign Museum in Cincinnati in October 2017 that I belatedly became aware that The History Press was publishing a series of books on fading ads. I made an inquiry, received a positive response, and, as they say, the rest is history.

Books such as this may be of interest to many constituencies: people interested in advertising and advertising history, people who view these ads as examples of graphic design and commercial art and individuals interested in product history, both products that are "history" and those that are still with us. If one regards fading ads on walls as an intrinsic part of a building, they can be of interest to individuals committed to architectural preservation, whether professionally or not. Even without a specialized interest, anyone who loves what is old and is nostalgic for what has passed may get a kick from the pictures and text in this volume.

I hope this book will encourage others to locate and photograph ads in their neighborhoods. I am sure there were and are many ads I never saw. The pictures tell their own story. Any errors in the text or in my best guess as to when the ad was painted are solely mine.

FADING ADS

What are fading ads? They are advertisements that were painted long ago on the sides of brick and other buildings around the world. Also called "ghost signs," these images were painted with lead paint, which was absorbed by the soft material beneath. After years of weathering, all that often remains of these images are traces of paint, especially white paint, that has leached out of the brick, giving it a "ghostly" appearance. The term "ghost signs" tends to apply only to ads on brick walls. "Fading ads" is intended as a more inclusive term for ads on such other surfaces as metal, stone and wood.

Where are these images found? They are prevalent throughout North America and Western Europe. They are found in metropolitan areas and towns of all sizes. They can be as large as twenty by forty feet, as small as four by six feet. Ads applied high on big walls would need to be larger, while ads lower down would need to be smaller to be easily seen by pedestrians. They were painted mostly on side walls at right angles to passersby.

What do these fading images advertise? Just about everything. Many tout national products such as Coca-Cola, Aunt Jemima Pancakes or Nash cars. Others promote or identify strictly regional or local products and services. In an ad for "Ladies and Gents Clothing" with no address or phone number, one can deduce that the store being advertised was probably in the building on which the ad appears. The majority of ads contain only wording, mostly in white, but

approximately 10 to 20 percent are illustrated, typically in color, or so I calculated from all the ads collected in the four volumes on fading ads that I had in hand while writing this book, as listed in my bibliographic notes.

When were these fading ads created? Fading ads are not dated in the manner of most fine art. Dating them requires making a guesstimate. Certain factors can assist us in this process. Can one discover when the product was manufactured? Lettering styles and types of illustrations vary over the decades, so they can also provide clues. Some ads have phone numbers, and the format of these numbers offers additional clues. Three numbers after the letter exchange probably indicates a date before 1920. A letter exchange plus four or five numbers indicates four decades before the 1960s, when the all-number system started. The wording in ads can also provide a clue. When you see the word "gents" or the term "misfit clothing" in an ad, you know from the usage that the ad is antiquated. The ads illustrated in this book date, in my best judgment, from the 1890s to a few years after World War II, with most from the first four decades of the twentieth century. Ads on buildings and other surfaces from earlier in the nineteenth century can easily be seen in photographs in history books and other printed materials. Keep in mind, however, that no photographs were taken before 1839, when photography was invented.

Who painted the ads? Ad painters were traditionally called "wall dogs." William Stage, in his excellent book *Ghost Signs*, explains that the term came about because the painters worked like dogs. One chapter is devoted to interviews with several painters, and another describes in detail how they went about their work. His book contains many illustrations from all over the United States. Many ad painters worked for large sign companies in major cities, while others worked independently. Few signed their names, although the major sign companies often attached their company names at the bottom. The heyday of fading ads was the first half of the twentieth century. They later declined for many reasons, including the development of superhighways, the proliferation of billboards, the increasing costs of painted ads and because modern buildings are rarely made of brick and contain large glass surfaces.

How did I become interested in fading ads? In 1979, I began working at a hospital in the southwest side of Chicago, and as I was driving back and forth to work, I began to notice these interesting ads in older neighborhoods of the city. I began taking pictures. I would accumulate lists of ads and return to shoot, mostly on Sunday mornings when there was less traffic and street activity. My time was limited, because in the 1980s I was also working full-time and usually had a part-time job in addition, plus the usual family and taking-care-of-the-house activities. This meant that I could not always get a picture on the sunny

side of the building or when a car was not partially in the way. There were times when gaining access to, say, the third floor of a building would have yielded a vastly better shot than standing on the sidewalk. I would take pictures in other parts of Chicago as I traveled about, but the largest percentage are on the South and West Sides, which comprise a larger area of Chicago than the North Side. A website developed by Nicole Donohue, Ghost Signs—Traces of Chicago History, focuses mostly on the North Side of the city. Her images were taken about twenty years after most of the images in this book were shot. One can also google "Chicago Ghost Signs" and find many images, a few of which are of the same signs that are pictured in this book. Had I the time and foresight years ago, I could have more systematically strolled major streets and side streets to find ads that have by now no doubt become more faded or disappeared altogether. Bear in mind that I am an amateur photographer who did this work on a limited part-time basis. I also worked independently and not as part of a group, such as the one described by Frank Jump in his wonderful book *Fading Ads of New York City*. I started before the age of the internet and did not consult it in regard to fading ads until recently.

Want to look for ads yourself? Great! I suggest you keep your eyes open as you walk about your neighborhoods. If you use a car, have a driver while you are the spotter; otherwise you might do what I did once: go through a red light and almost cause an accident. Luckily, the Chicago police were not in view. You will probably need both telephoto and wide-angle lens capacity. I will not advise you what to do if the best shot is from the middle of a busy street. Remember that fading ads can be found in big towns and small. I suspect that many small and medium-sized towns have proportionately more ads still intact than metropolitan areas, where more is torn down to allow for new buildings.

How is this book organized? I debated whether I should organize my work by subject matter or area of the city. I decided the organization would be geographic, as Chicago is roughly divided into the South, West and North Sides, plus the Loop area, our downtown. Within these areas are subsections on such topics as auto, food, drinks, the particular subsections unique to each area. For example, because the South Side has an Automobile Row Landmark District, which hosted many auto dealers and related services early in the twentieth century, the South Side chapter contains an auto section, while not all chapters do.

The caption for each picture gives the following data: key word or words in the ad, the year the picture was taken, the estimated decade in which the ad was painted, the location and current status if known. Only rarely is the exact date the ad was painted known. Location is usually given by the closest intersection but sometimes by the exact street address. I have not added

"Street" or "Avenue" to street names. For example, "21st" indicates "21st Street" and not "21st Place." I had hoped to return to the sites of all the ads in this book but soon realized that this task required much more time and energy than I could manage. When the current status of an ad was known, it is indicated as follows: lost, present, obscured, trace remaining and location unknown. If there is no notation, it means the site was not visited. About two-thirds of the ads at located sites were classified as "lost."

What do fading ads look like when you first see them? What follows is a rough-and-ready typology of fading ads, from those that are virtually not fading to those that are so faded one can make out nothing or almost nothing.

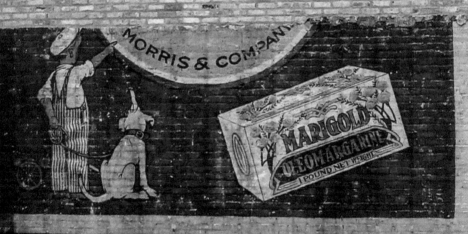

1. PRISTINE OR VIRTUALLY PRISTINE. This is the ideal situation in which to find an ad, but it is rare. Only one such ad appears in this book, that of Marigold Margarine. To find an ad in this condition requires more than its being relatively protected from the weather. It usually means that an adjoining building was erected not long after the ad was created and whatever gap existed between buildings was sealed at the top. An ad in color and with an image adds to the interest.

LEFT Marigold Margarine, 2007, 1930s, Lincoln ½ block north of Menominee. East half now covered.

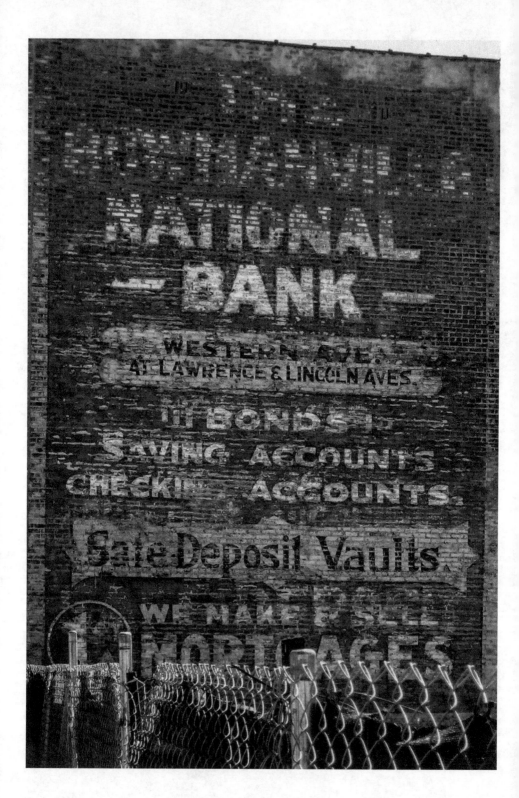

2. VERY INTACT. The wording and any image, if present, are clear, although there may be some area of damage. If the image is quite old, eighty years or more, it means that the ad has been protected for all or most of its life or may have been on a side away from the worst of local weather. An example is an ad for Bowmanville National Bank. The word "Bowmanville" is partially obscured, but the rest is quite readable and the color is strong. The ad is facing north.

LEFT Bowmanville National Bank, lists various services, 2009, 1920s, 6300s North Western. Present.

3. AVERAGE. These are by definition the most frequent. They are mostly readable and have recognizable images but are showing obvious wear and tear. Paint has chipped off or worn off and may be missing in an area, or the underlying brick has deteriorated, eliminating part of the ad. The average ad has text only. The ad for Blue Label Ketchup is a good representative of this category, although it has a picture.

RIGHT Blue Label Ketchup, Sauce Made from Fresh Ripe Tomatoes, 1981, 1930s, Stony Island north of 71st. Ad painted over in 1982.

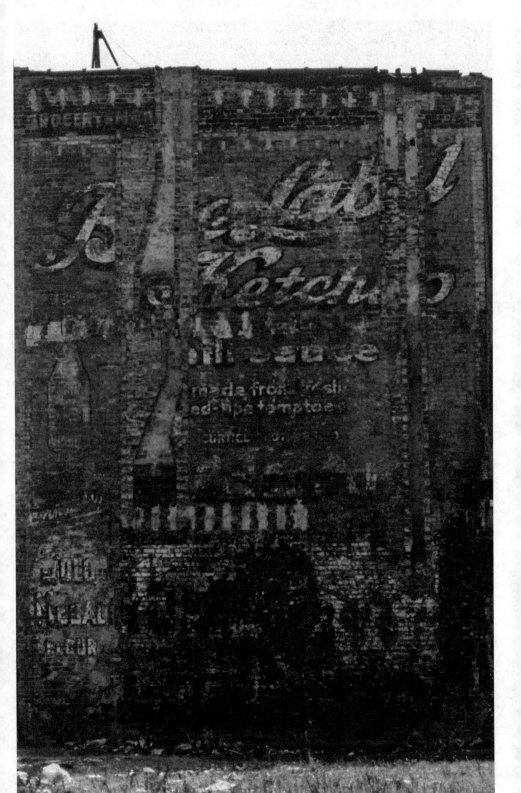

Example of very faded ad; at bottom one can barely read: Lub, a.c. Motor Plating, 2001, 1950s, near 1900 South Michigan.

4. REALLY FADED. One can hardly tell anything about an ad like this. A border may surround the ad, but just as often, the ad is small and text only. The border may offer a clue, and specks of remaining paint or a ghostly emanation may be further evidence.

5. SEVERAL OTHER TYPES OR CONDITIONS: large walls on which several ads have been painted that are individually in various conditions; ads painted over previous ads so that parts of both are seen with varying degrees of deterioration, one ad obscuring another; ads damaged by later construction on a wall, such as inserting a window or door; ads partly obscured by billboards, posters or other signage of recent vintage; and ads to which the remains, such as plaster, of an adjoining building are still present. Ads on surfaces other than brick are included in this type. The illustration of this type shows various ads, some side by side, some overlapping and including two addresses and at least two types of products. It also shows plaster remains on the wall obscuring the ads. This image was painted over shortly after the picture was taken.

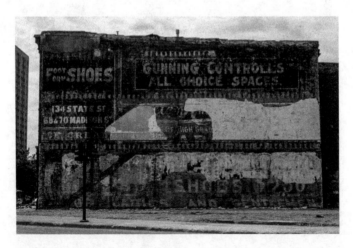

ABOVE Multiple ads on one wall: 134 State, 68 and 70 Madison, Shoes $2.50, High Grade, 1982, before 1910, West Washington at Ogden. Painted over in 1982.

Not all fading ad devotees will find these categories entirely right or useful. They are rough guidelines for describing what one sees. I rarely use these categories in describing images in the chapters that follow, identifying the pictures instead by city area and type of product or services advertised. The typology is offered here primarily as an aid to help readers understand how to view fading images and the range of qualities they might see.

Four chapters cover fading ads in the South, West, Loop and North parts of the city. Chapter 5 has pictures of ads on surfaces other than brick. I have been a little arbitrary if an ad is southwest or northwest, as no hard and fast line exists for determining exact boundaries. Because most of the photographs in this book were taken twenty-five to almost forty years ago, one can assume that their condition has by now greatly deteriorated if they still exist at all. Chicago has for some years had a policy of rapid teardown of unmaintained buildings, and of course, most fading ads were and are on old buildings.

THE SOUTH SIDE

The South Side is the largest of the city areas, extending from the Loop to a few blocks south of 130th Street. The first group of ads, "Transportation," has more entries than are found in other areas because from the 1910s to the 1930s, an area south of 14th Street on Michigan Avenue was known as Automobile Row. This area and some blocks of adjoining streets are now designated as a Chicago Landmark District. Makers of automobiles that are still sold today had showrooms there, along with showrooms of such obsolete brands as Hudson (my dad owned one), Locomobile, Marmon and Pierce-Arrow. Over the years, 116 brands of cars were sold in this area. A few years ago, one dealership and a repair shop still survived in the area.

TRANSPORTATION

THE DAYTON ROYAL TOURIST. The Stoddard-Dayton Company made high-quality and fairly expensive autos from 1905 to 1913. The Royal Tourist model was one of its larger cars, featuring two rows of seats. The dates it was in business help pinpoint the date of this ad. John A. Stoddard and his son Charles were the principal owners of the company. After the senior Stoddard made a fortune in agricultural equipment manufacturing, he decided his future was in cars and sent his son to Europe to evaluate the European auto industry. They decided that electric and steam-powered cars were already out of date and made many models powered by four- and six-cylinder gas engines. Essentially, they made handmade cars. Their lower-end cars had over fifteen coats of paint and were sanded between each coat. Their limos had at least thirty layers of paint. Cars were extensively tested at the factory and on the road, and engines were broken down and reassembled before going to the showrooms. As you might imagine, the Dayton was not a low-price car of its day. Runabouts started at $1,250 and the limo at $3,500 ($31,766 and $88,945 in today's dollars). But by 1912, the company had over-expanded, and its costs grew too high. It was taken over by another company. Charles Stoddard soon left to form a new auto company. The successor company soon went bankrupt. The Maxwell Car Company (Jack Benny owns one of these in his radio show) bought some Dayton assets and sold a few models of Dayton for a while.

OPPOSITE Dayton Royal Tourist, 1980, 1911–13, 1470 South Michigan. Lost.

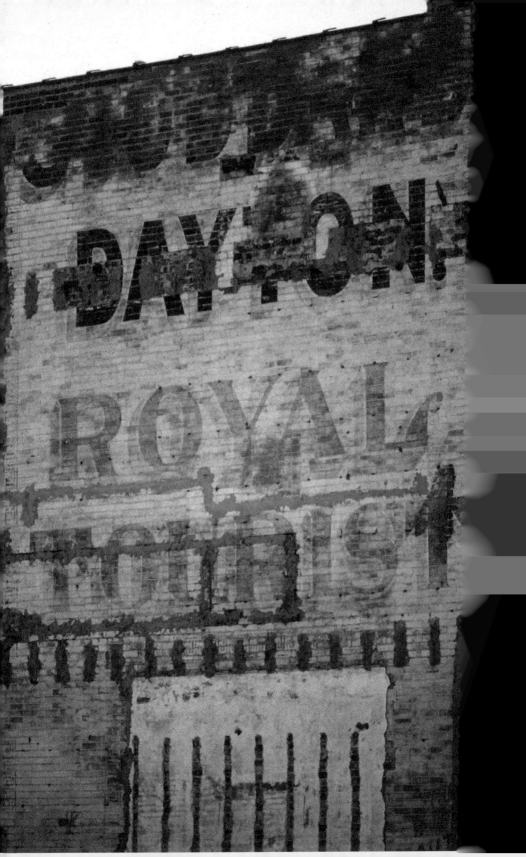

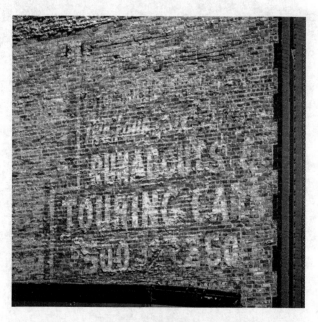

TOP Runabouts
and Touring Cars
$500 to $1250, 1980,
1920s, 1400s South
Michigan. Lost.

BOTTOM Nash,
2001, 1930s, near
Cullerton and
Wabash. Lost.

RUNABOUTS. This ad for "Runabouts and Touring Cars—$500 to $1250" is located at the north edge of Automobile Row. It is possible that there was a showroom in the building that featured this ad. "Runabouts" is the term, now antiquated, for small and lightweight autos with cloth roofs that could be removed. We would call them "convertibles" today. A synonym was "roadster." Touring cars were larger and would seat more passengers. Whatever brand is referenced here, it seems they were not Daytons, which were sold at a much higher price range.

NASH. Nash cars were made from 1916 to 1954. I remember when I was a kid the Nash had a streamlined look, earlier than most cars. In those years, there were fewer car models, and many kids could identify about all of them. Nash was a successor to an earlier company that produced the Rambler. The Rambler was started by an Englishman, Thomas Jeffery, who initially built bicycles. He invented a pneumatic bicycle tire, which he sold to the Dunlop Company. He came to America and in Kenosha, Wisconsin, built his first Rambler auto, a one-cylinder vehicle, in 1897. In 1898, he developed a production line and was the second-largest automaker in the United States. He kept improving his cars and, imagine this, produced a four-wheel-drive vehicle in 1910.

In 1916, Jeffery's son sold the company to Charles Nash for $10 million. Nash was a successful entrepreneur, made many automotive innovations and expanded the company. By 1920, Nash had sold about twice the number than the fifty thousand Dayton sold at its heyday. During the Depression, Nash made innovations, such as a synchronized transmission, central chassis lube, a shift lever on the dash instead of the floor and climate control with air conditioning, and it was the first to use a sealed beam headlight. Nash was known for high-quality cars at relatively low prices. Nash's best years were in the late 1940s and early 1950s. In the mid-1950s, Nash and Hudson merged to form American Motors, and the Nash brand disappeared. American Motors produced a car with the Rambler name. I know. I owned one.

CADILLAC. Most of us know the Cadillac car as the premier product of the General Motors Corporation. It was not one of the original brands of General Motors but was bought by the company in 1909. The first Cadillac was manufactured in 1902, a runabout with one row of seats and a tonneau with two rows. Like other car manufacturers, GM kept improving Cadillac engines by adding cylinders and horsepower. It made the first fully enclosed car in 1906. Over the years, GM, with its stable of several cars, developed interchangeable parts, which helped in mass production. Cadillac enhanced its electrical systems and made "clashless" transmissions. GM was the first automaker to produce a V8 engine and use a steel roof, and it was known for its chassis for ambulances. Its limos are well known to this day. GM's cars have been status symbols in America for decades. A down note: It was GM's policy not to sell to African Americans until 1934. With a policy change, sales increased considerably. One wonders if this was a business decision or one based on a change of heart. As a curious last note, Cadillac was the first car manufacturer to use Phillips screws as a way to speed up the production line.

OPPOSITE Cadillac Motor Car Company, Showroom No 1. 2001, 1930s, 2414 South Michigan. Lost.

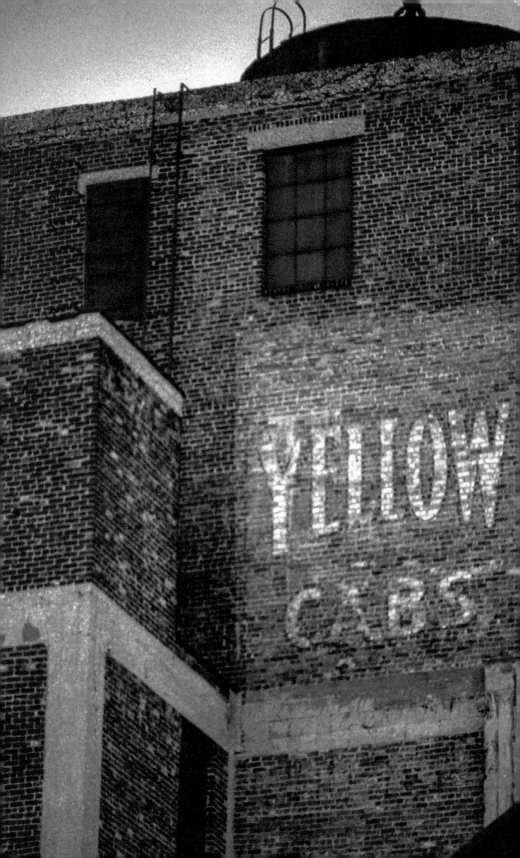

YELLOW CAB. The original Yellow Cab Company was a Chicago company founded by John Hertz and a partner in 1907. Hertz was from Austria but grew up in Chicago. It was apparently thought that the color yellow made cabs easier to spot for hire and would result in fewer accidents. The partners had originally been in business to trade cars but shifted to using their cars for cabs. They incorporated in 1915 with 40 cabs and, by 1925, had the largest cab company in the world, with 2,500 cabs. The Yellow Cab Manufacturing Company made the cabs the Yellow Cab Company used and in time the cabs used by the Checker Cab Company, the same cars painted differently. Yellow made some innovations such as using balloon tires and having automatic window washers. It used telephone dispatching before other cab companies did. In 1929, Hertz sold his shares to buy a company in the rental car business, and the name Hertz is still very much with us.

The new majority owner of Yellow Cab, Morris Merkin, also owned Checker Cab and its car manufacturing company. By 1935, Yellow was no longer a corporation but privately owned for the next several decades. Eventually there were many Yellow Cab Companies. A few years ago, the Chicago Yellow Cab Management Company had 2,000 cabs leased to drivers. With Uber and other such new enterprises, cab companies have fallen on hard times. There are fewer cabs and drivers, drivers are earning less and the required cab medallions have lost much of their value.

LEFT Yellow Cabs, 1981, 1940s, 2120 South Wabash. Lost.

WESTERN AUTOMOTIVE. I believe this ad refers to the Western Auto Supply Company. This company was an innovator in franchising the individual Western Auto Stores. It was started in 1909 by George Pepperdine. If that name sounds familiar, it may be because this same gentleman founded Pepperdine University. While started in Kansas City, Missouri, the company eventually expanded to over four thousand stores, mostly in smaller towns. Beginning in the 1960s, the franchiser was purchased over the years by various companies, including Sears Roebuck and Company. By 2003, this chain was essentially out of business, although the name Western Auto could still be legally used for a while. This company at one time marketed the famous Western Flyer bicycle and many types of products for the car.

WESTERN AUTO SALES. The remaining text for this ad reads "Second Hand Cars Bought Sold and Exchanged." We know cars are bought and sold at lots, but exchanged? Hertz traded cars. This ad is the bottom portion of an ad that was found in the south Loop, but because it was located only a few blocks north of Automobile Row, I included it here. The picture of the whole wall is found in the last section of the Loop chapter.

TOP Western Automotive, Merchandizing, Automotive Products. 1981, 1950s, 21st and Wabash. Lost.

BOTTOM Western Auto Sales, Second Hand Cars Bought, Sold, and Exchanged, 1997, 1930s, 1014 South Michigan. Obscured by construction fencing. Future status?

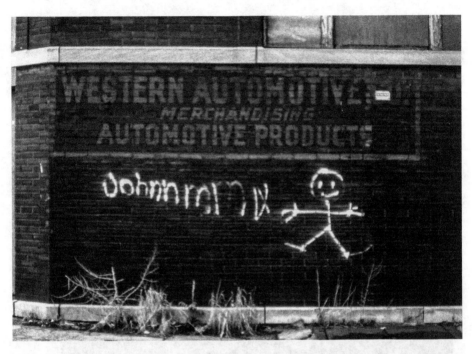

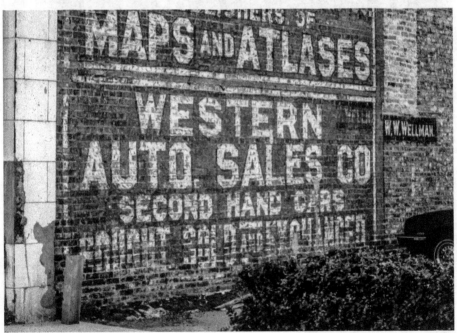

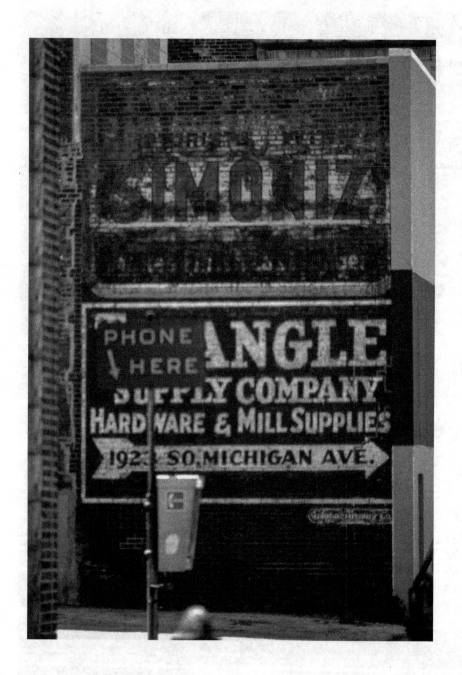

SIMONIZE. This product name became almost synonymous with polishing a car no matter which polish one used, although this may be less so now, as fewer people polish their own cars. Products from this company are available in every auto supply store I have ever visited. It was started in 1910 by George Symonds, who developed a carnauba wax for car finishes. The company was reorganized in 1912 as the Simons Manufacturing Company. It was subsequently purchased by new owners, who renamed the product Simonize. The company manufactures numerous products to enhance the appearances of cars. The ad pictured here was found about two blocks north of where the company headquarters was once located. In recent decades, the company has had several corporate changes.

OPPOSITE Simonize (Also: Triangle Supply Company, Hardware and Mill Supplies), 1980, 1940s, 1900 block South Michigan. Lost.

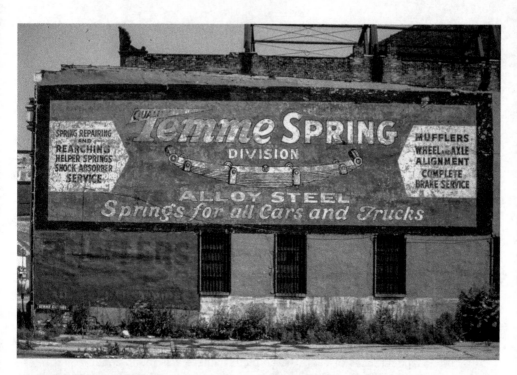

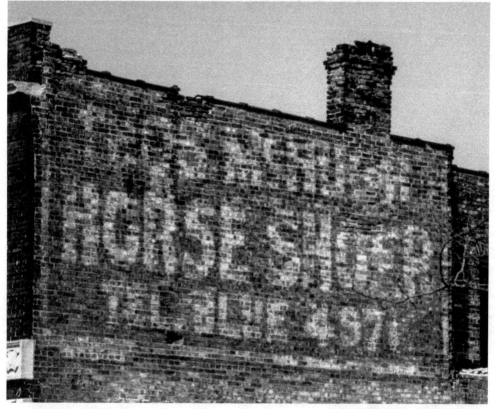

TEMME SPRINGS. Temme was a local manufacturing company that initially made leaf springs but later serviced cars, primarily doing spring, brake and clutch repair. It was founded in 1910. I found a website for this company but at the listed address found only a wooden fence. An inquiry at a nearby auto supply store indicated it had moved some years ago. A website for an auto trim company with the Temme name in a western suburb lists the company as closed. Apparently, this company no longer exists.

HORSE SHOER. I found this ad about a mile and a half from my house. I would guess Mr. McHugh has not shod any horses for some time. However, as late as the 1950s, when I first came to Chicago, and perhaps for a while thereafter, there was still a bridle path along the Midway between 59th and 60th Streets, which was the Midway for the Columbian Exposition in 1893.

TOP Temme Springs (lists other services), 1980, 1950s, 1500 block South Wabash. Obscured by building.

BOTTOM Thos. McHugh Horse Shoer, Tel. Blue 48..., 2001, 1920s, 4300 block South Cottage Grove. Lost.

FOODS

BLUE LABEL KETCHUP. This product was made early in the twentieth century if not before. It is illustrated in the Introduction. Most of what I found on the internet for Blue Label was about collecting old bottles or ads. One ad was from 1911. This product was made by the Curtice Brothers in Rochester, New York. One hundred years ago, the company's ad writers produced the following newspaper blurbs: "Pure and unadulterated containing only those substances recognized and endorsed by the United States Government," "Keeps after it is opened," "Cooked just a little, that the natural flavor may be retained," "Seasoned delicately" and "Put up in sterilized bottles." The sauce was apparently widely advertised. The same wall also sports a Gold Medal Flour ad.

SCHWEIGER DRY GOODS. Schweiger appears to have been a general store that sold many products for the home, including New England Condensed Minced Meat. The store was most likely located in the building on which this ad appears.

RIGHT Schweiger Dry Goods, Notions, Toys, Crockery, Glass, Tin Ware, New England Condensed Mince Meat, 1981, 1930s, South California North of Polk.

WE...
OODS. NOTIONS. TOYS
RY GLASS & CHINA

CONDENSED

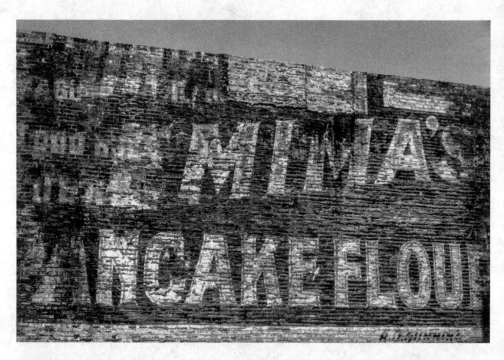

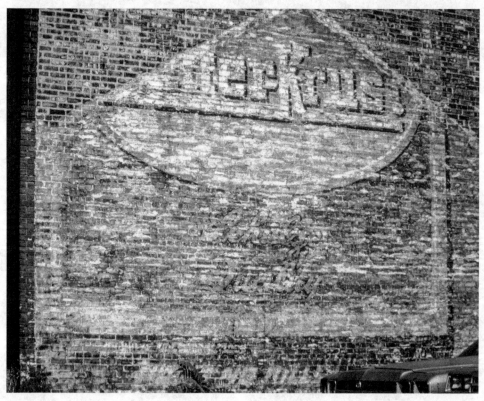

JEMIMA'S PANCAKE FLOUR. This product, first produced in 1889, is made by the Quaker Oats Company of Chicago. The Aunt Jemima character was derived from minstrel shows, which involved stereotypes of African American characters. Some are offended by this usage; others view it nostalgically. A song, "Aunt Jemima," was written in 1875. In 1888, a flour mill in St. Joseph, Missouri, had a surplus that it sold as pancake mix. To enhance sales, it located an "Aunt Jemima" character to promote the product, but the owners sold the company when the flour did not sell well. The new company hired Nancy Green, a former slave, as spokesperson, and she filled this role until her death in 1923. She held a cooking display at the Chicago Columbian Exposition. Quaker Oats bought the company in 1926. A new Aunt Jemima appeared at the 1933 Chicago World's Fair and played that role for fourteen years. Later Aunt Jemima appeared on television. This product apparently sells well to this day.

BUTTER CRUST, a soft white bread of the day. Bread ads were quite popular. I believe this was made by the Schulze Bakery.

TOP Jemima's Pancake Flour, 2001, 1910s, 92nd and South Chicago. Lost.

BOTTOM Butter Crust Schulze Quality, 1981, 1930s, 22nd near Sawyer. Lost.

BUTTERNUT. This bread was one of many brands popular for sandwiches and toast before and after World War II. It was baked initially by the Schulze Bakery, located at the intersection of Garfield Boulevard and Wabash Avenue. This building was erected in 1914 and is still standing. It is covered in white and blue terra cotta and in 1982 was placed in the National Register of Historic Places. In the fall of 2017, I had the chance to see this otherwise closed and unused building, as it was on tour for Open House Chicago, a two-day annual event sponsored by the Chicago Architecture Center. There are plans to rehabilitate the building. Many baked products besides bread were made in the building at various times, including Hostess Twinkies, although the Schulze Bakery did not invent them. The bakery closed in 2004. This ad is in the "lost" category, but a similar ad is still visible on both sides of a building not far away in the 2000 block of West 18th Street.

HYDROX. Sunshine Biscuit Company made this chocolate sandwich cookie in 1908. Some claim it was the first sandwich cookie. For much of its existence, the cookie was made by Sunshine, which had several successive corporate owners. By the late 1990s, it was off the market for a while but has since been acquired by the Leaf Company, which has returned it to its original formulation.

TOP Schulze Butternut, 1981, 1930s, 21st near Rockwell. Lost.

BOTTOM Hydrox, 1980, 1950s, 24th east of Martin Luther King Jr. Lost.

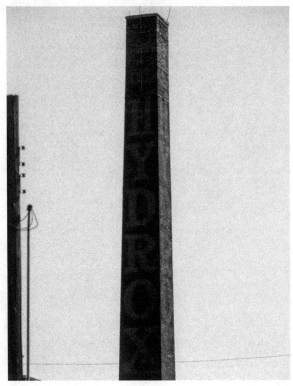

JAYS POTATO CHIPS. This widely distributed snack food was first produced in Chicago in 1927. The company was founded by Leonard Japp Sr. It originally made pretzels but expanded to potato chips and other snack foods. During World War II, the company was rebranded Jays from Japps, for obvious reasons. The family sold the company in the mid-1990s but some years later reacquired it and then sold it again. Now Jays' products are a subsidiary of Snyders, a pretzel and snack food maker.

OPPOSITE Jays, 2001, 1960s, 19th and Michigan. Lost.

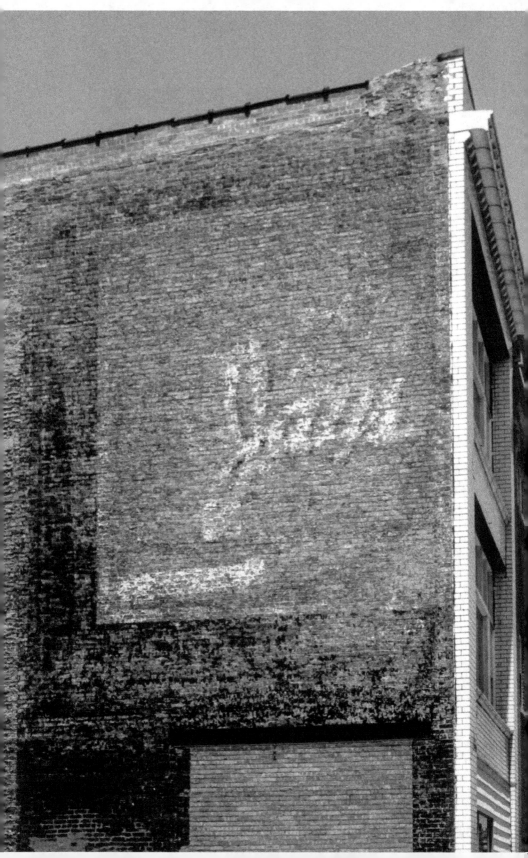

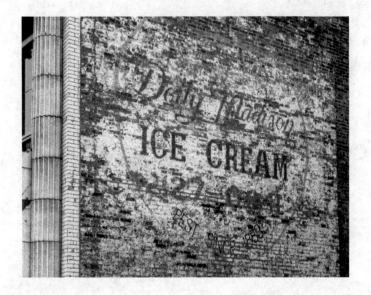

DOLLY MADISON. Named after the wife of President James Madison, the bakery was started in 1927. It made ice cream and Hostess cakes. The company underwent various corporate changes. Eventually, Hostess Brands was about to go out of business until bought by private investors. Its various products, including Twinkies, are still on the market.

QUALITY PRODUCTS. Here is a mystery bottle. We know only of its high quality because the ad says so.

ABOVE Dolly Madison, 2001, 1960s, 1700 block South Michigan. Lost.

OPPOSITE Quality Products Car and Home, 2001, 1960s, Cermak and Michigan. Lost.

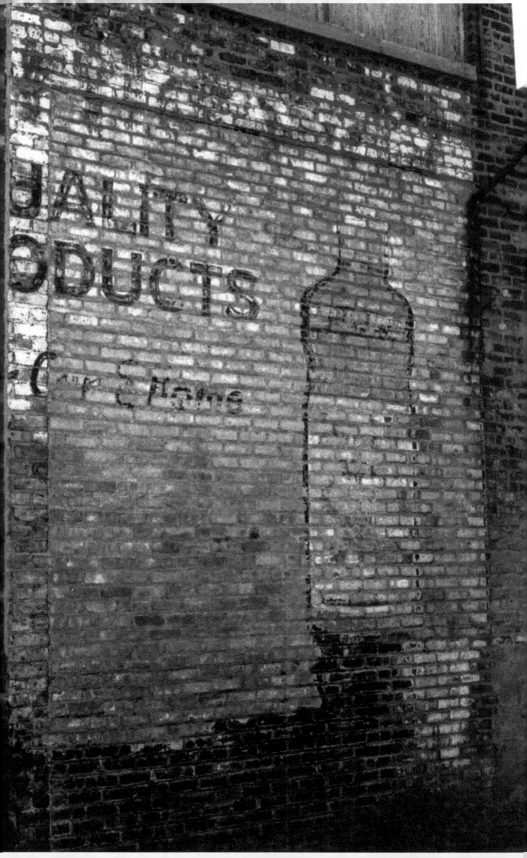

BEVERAGES

Advertisements for soft drinks and various alcoholic drinks were common, as were ads for foods, in the years wall ads were popular. Often identical or quite similar ads were put up in a number of locations in the city.

SOFT DRINK PARLOR. When no address or phone number is given, it usually means the business was in the building on which the ad appears. But this wall also advertises Schulze Butter Nut Bread. It is not clear if this means the bread was sold there or if this is just a product ad. My guess is the soft drink parlor was on the premises. A parlor indicates that you could sit down at a table.

OPPOSITE Soft Drink Parlor, Schulze Butter Nut Bread. 1981, 1920s, 2000 block West 18th. Lost.

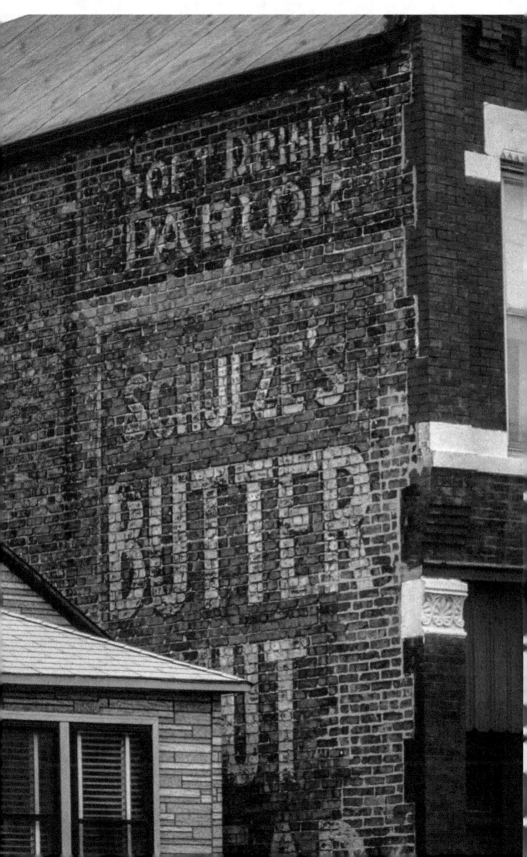

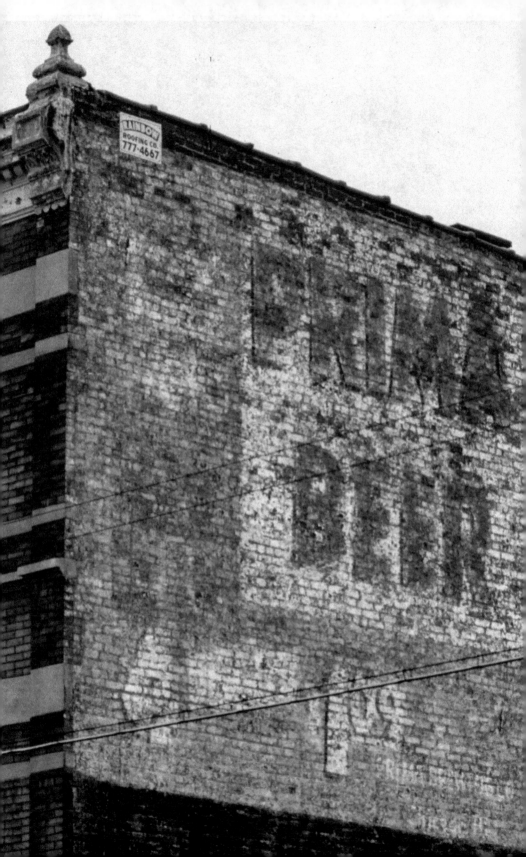

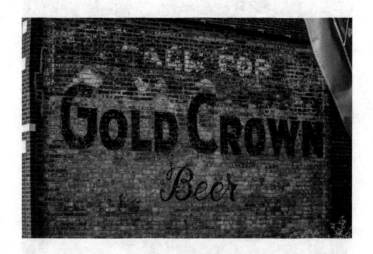

PRIMA BEER. Prima was a Chicago beer started on Goose Island in 1890. The brewery's street address was originally 1440 North Halsted Street. Goose Island is located in the north branch of the Chicago River. Prima had the usual problems during Prohibition and was taken over first by one company, then another. Sales appeared to end in the late 1930s or early 1940s. I saw a photograph dated 1957 of a building with a Prima beer ad in a photography exhibit at the Art Institute of Chicago. Was this just an old ad that was never removed, or did Prima Beer have yet another short life? Prima had many ads around the city. On the internet, Prima beer ads are listed in four other locations in Chicago, but this location is not listed. The ad promises you can purchase four quarts for $1.09. That's a buy!

GOLD CROWN. Whiskey, beer and ale containers from Dawson Gold Crown can be found for sale online. We cannot tell from this ad which of its products is being advertised.

OPPOSITE Prima Beer 4 Qts, $1.09, 1981, 1950s, 22nd west of Washtenaw. Lost.

ABOVE Gold Crown, 1981, 1940s, 5834 South Kedzie. Lost.

WHISKIES. Whether this ad was initially for a brand of whiskey or an inducement to enter the premises and partake is not clear. This ad was in the area referred to as the "levee," Chicago's red-light district at the turn of the twentieth century.

CIGARS, DRAUGHT BEER. These two seem to go together, and I'm sure you could buy them both on the premises.

ABOVE Whiskies, 1984, 1930s, Near 18th and Wabash. Lost.

OPPOSITE Cigars...Draught, 2001, 1930s, near 93rd and Houston.

FOR THE HOME

Here I have listed stores that sold products for the home, such as furniture stores, as well as companies whose products would keep you warm in Chicago's winters.

BOSTON STORE. This department store chain was originally founded in 1897 in Milwaukee. In time, there were a number of Boston Stores in various cities in the Midwest. During the Depression, a majority of the store's employees went on a "white collar strike," which was unusual, as ordinarily factory workers went on strike. Over time, the company was purchased by different department store chains and the name Boston Store virtually disappeared. There was a much larger Boston Store ad in the Loop, where its store was one of the several department stores housed on State Street. This ad displays only "BOS" but is no doubt an ad for the Boston Store.

OPPOSITE Bos(ton Store), 1981, 1920s, near 15th and Wabash. Lost.

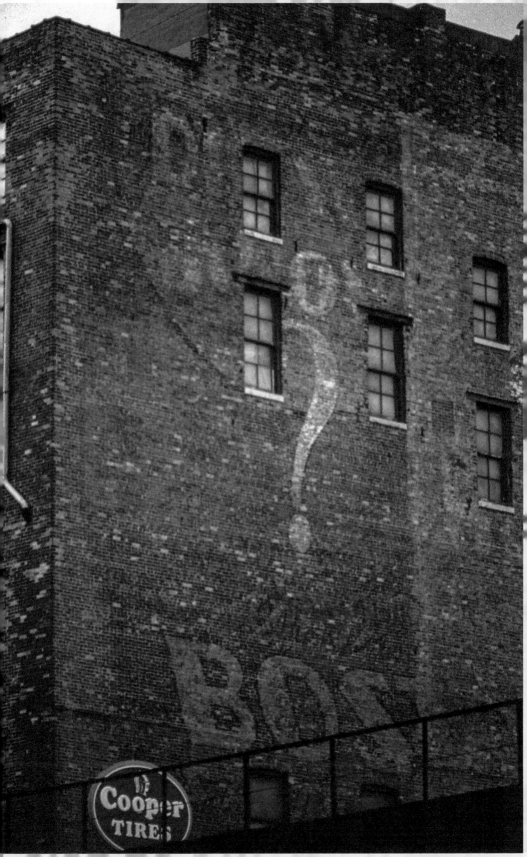

STIEFFEL FURNITURE COMPANY. The ad is on the side of the building where the store was located. Three men with the same last name ran the company, perhaps a father and two sons. Many years later, the basement of that building was one site for a well-known Chicago pizza chain. Stieffel advertised "Quality Furniture" but also "Liberal Credit Terms." This was the period before credit cards, when many businesses, including smaller ones, arranged their own credit with customers. Usually it involved so much down and so much per week or month.

HENRY STUCKART. Stuckart ran a company selling "parlor goods," living room furniture in today's parlance. He was born in 1853 and died in 1925. At one time, he was a fairly well-known Democratic Party politician who served at various times as alderman, Cook County assessor and county treasurer. His father founded the business located at 2519 South Archer Avenue. This ad was located only a few blocks from the store.

TOP Stieffel Furniture Co., Quality Furniture, Liberal Credit Terms, 1981, 1940s, 63rd west of Kedzie. Lost.

BOTTOM Henry Stuckart & Co. Parlor Goods, 1984, 1920s, southeast corner Archer and Halsted.

UPHOLSTERING. This ad is one of the few more recent, from the mid-twentieth century. The ad also refers to carpet cleaning and mattress making, which perhaps were done on the premises.

FLORENCE DRAPERIES. Another mid-twentieth-century picture for a service for the home.

TOP Upholstering and Carpet Cleaning, Mattress Making, 1984, 1950s, near 47th and Langley. Lost.

BOTTOM Florence Draperies, 1981, 1960s, 62nd Place and Kedzie. Lost.

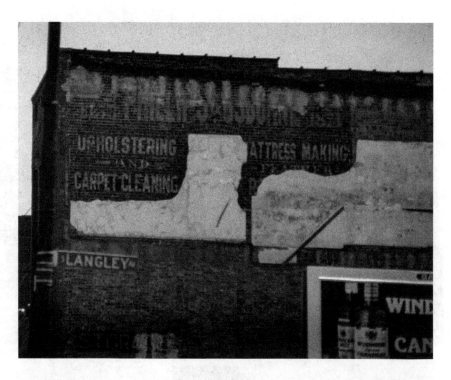

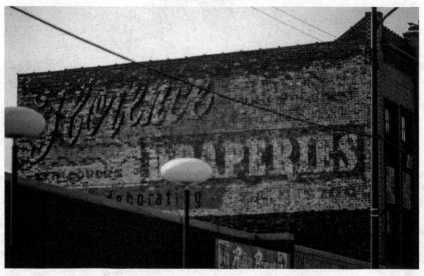

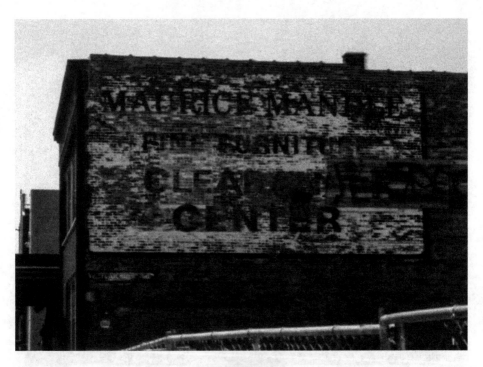

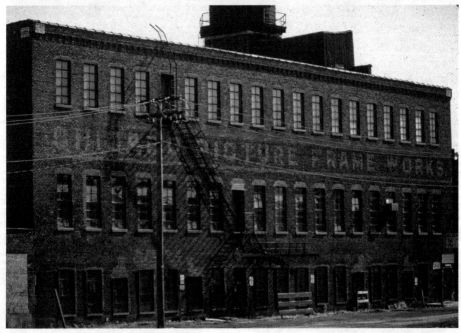

MAURICE MANDLE. This company was founded in 1930. At some point, it became known as a discount furniture dealer selling good quality furniture. I know because in the early 1970s my wife and I bought our son's bedroom furniture from the store at this location. In 1990, the store was closed and converted to showroom galleries open to decorators and their clients. It no longer seems to be in business.

CHICAGO PICTURE FRAME WORKS. Many companies in the late 1800s and early 1900s used the word "works" as part of their name. After all, work was done there. I also found an ad for "Chicago Cork Works," but that ad is not included in this book.

TOP Maurice Mandle Fine Furniture, Clearance Center, 2001, 1960s, 1500s South Michigan. Lost.

BOTTOM Chicago Picture Frame Works, 1981, 1920s, Cullerton and Western. Lost.

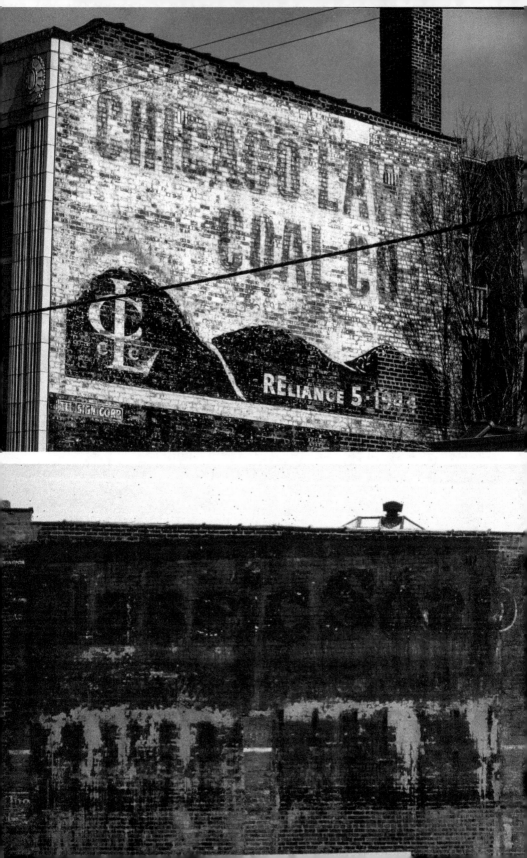

CHICAGO LAWN COAL. This ad with its twin coal piles was obviously put up before Chicago banned the use of coal for home heating. Chicago Lawn is one of the more than seventy named community areas in Chicago and is located on the southwest side. It was the scene of the Reverend Dr. Martin Luther King's famous march for open housing in 1966, the march, unfortunately, in which he got hit in the head with a rock.

CLASSIC SOAP. I do not know if this was bar soap or laundry soap. In either case, there were many, many brands of soaps of both sorts.

TOP Chicago Lawn Coal Co., 1981, 1950s, 6100s South Kedzie. Lost.

BOTTOM Classic Soap, 1981, 1920s, 6416 South Cottage Grove. Lost.

WINKLER STOKERS. Most people today may not know what a "stoker" is, at least if referring to a product made for the home. Like the electric vacuum cleaner and the dishwasher, it was a product that was made to take drudgery out of home tasks. Once you loaded it with the right kind of coal, it automatically fed it into the furnace through a screw mechanism. Four members of the Winkler family founded the company, all of them winning national recognition for their work in heating and engineering. They began making stokers in the mid-1930s and were quite successful. The company name was changed in 1938 to the United States Machine Corporation. During World War II, it made military items. At one time, it had about one thousand employees and made oil and gas furnaces as well as coal furnaces. By 1953, it had become part of the Stewart-Warner Corporation. The Lebanon, Illinois plant closed in 1977. The first of many jobs I have had was taking care of my neighbor's stoker, which meant shoveling in the coal and also taking the "clinker" out of the furnace. A clinker is the unburned residue of coal that had to be removed to allow new coal to be fed into the furnace. So it wasn't so fully automated after all.

OPPOSITE Winkler Stokers, L...Extra Power, No Shear Pin, 1980, 1940s, 1600s South Wabash. Lost.

CLOTHING AND FURNISHINGS

"Furnishings" is a less commonly used term referring to accessories such as hats or gloves. The local stores listed in this section are difficult to research. If smaller and not widely known, they will not appear in Wikipedia or The Encyclopedia of Chicago. *Insurance maps give only building addresses and type of construction and identify neither ownership nor history.*

S. KAHN FURNISHINGS. This store probably catered to men and women. The ad also mentions "Oshkosh," formerly a brand of outerwear and work clothes. Oshkosh currently makes children's clothing.

OPPOSITE S. Kahn Furnishings, Oshkosh...Cost..., 1981, 1930s, 3335 West 63rd. Lost.

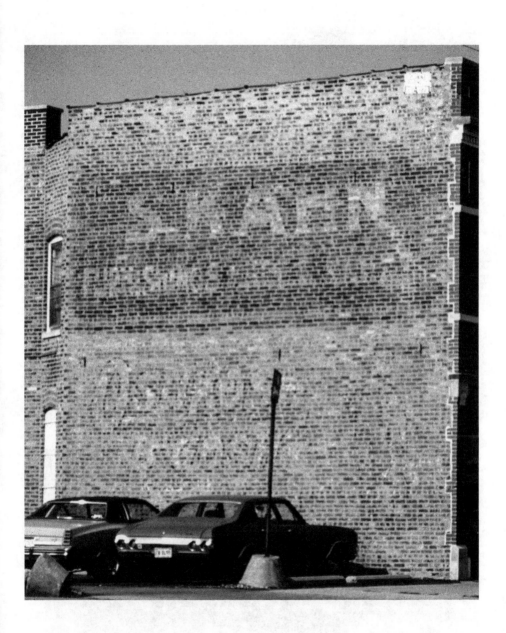

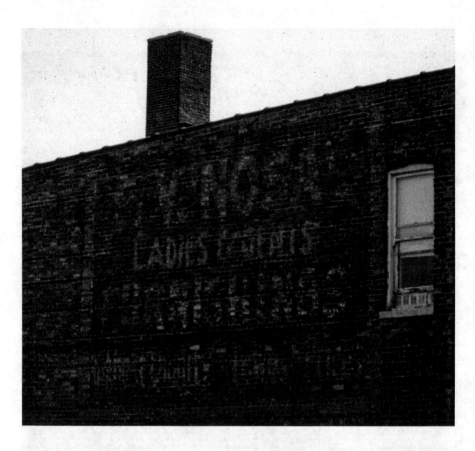

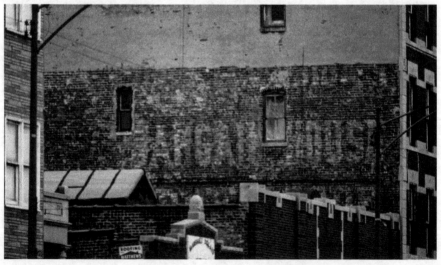

LADIES AND GENTS. An ad for a clothing store, probably on the premises.

BARGAIN HOUSE. If you went there, you should have had a bargain. But for what? I'm assuming clothing was sold there.

TOP S.V. Nosa...Ladies and Gents Furnishings, 1981, 1930s, 3000s West Cermak. Lost.

BOTTOM Bargain House, 1981, 1920s, Cermak east of Washtenaw. Lost.

END OF LIFE

O'HANLEY UNDERTAKER. His three-digit phone number after the Hyde Park exchange indicates the ad was painted no later than the mid-1920s. Hyde Park is a community area of Chicago, the one in which I live. However, this ad is farther south by about a mile from the south boundary of Hyde Park.

C. ADAMS UNDERTAKER. An undertaker prepares the body for the funeral service and burial. The term "undertakers" was often used as a synonym for "funeral home."

TOP O'Hanley Undertaker, Tel. Hyde Park 663, 1980, 1920s, 65th and Cottage Grove. Present.

BOTTOM Carl Adams Undertaker, 2001, 1920s, 92nd and Houston. Lost.

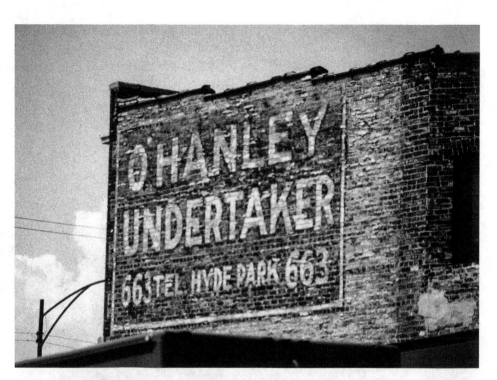

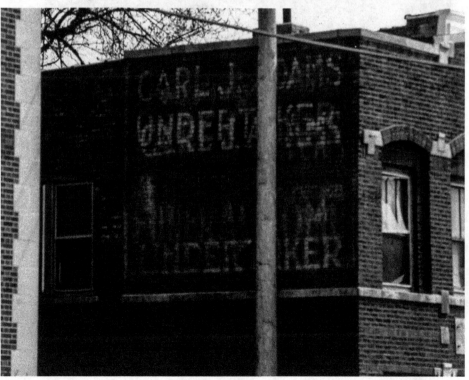

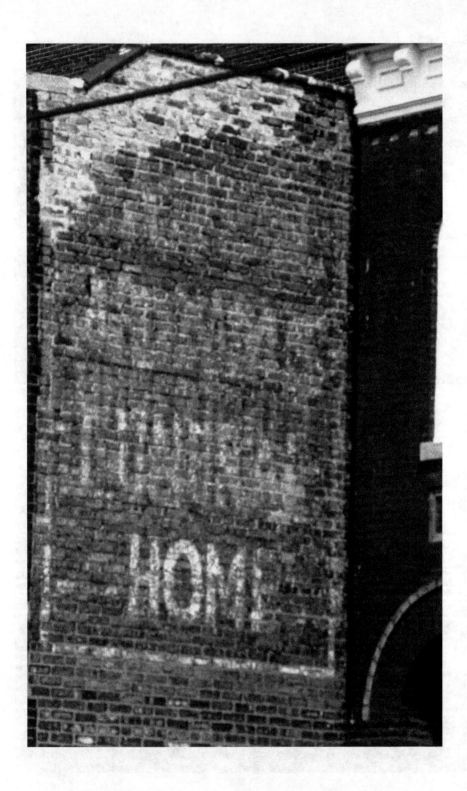

C. ADAMS FUNERAL HOME. This ad is located very close to the "C. Adams Undertaker" ad. Adams performed more than undertaker functions and did all those additional things funeral homes do.

OPPOSITE Carl Adams Funeral Home, 2001, 1920s, 92nd and Houston. Lost.

OTHER SOUTH SIDE ADS

These ads do not fit in any of the other South Side categories.

$40,000. I suspect this number indicates the capitalization of a small neighborhood bank.

POINSETTIA, an apartment building on South Hyde Park Boulevard, about two blocks north of the Museum of Science and Industry. It is listed in the National Register of Historic Places for its extensive use of terra-cotta ornamentation, which some consider among the best in Chicago. The style is Spanish Revival. The ad is at the top of this building, which would now be considered mid-rise. It's of pre-Depression vintage.

PARK SHORE APARTMENTS. This is a multi-story co-op apartment building also of pre-Depression vintage still well kept up and located on 55th Street just west of Lake Shore Drive. On the west side at the very top, one can just make out the last words of the ad, "...to seven rooms." This probably means there were three-bedroom apartments in the building, the largest size available. I'm familiar with the building, having gone to parties there. And my son worked at the entrance security desk, a very part-time job when he was in college.

TOP 40,000, 1988, 1920s, 21st and Wabash. Lost.

MIDDLE Poinsettia, 1983, 1930s, 5528 S. Hyde Park Blvd. Present.

BOTTOM ...To Seven Rooms, 2004, 1930s, 1755 East 55th (Park Shore Apartments). Present.

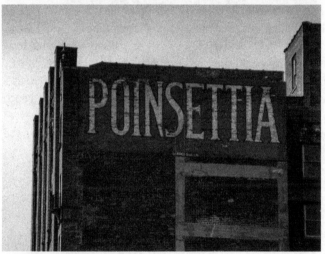

HOPKINS ILLINOIS ELEVATOR COMPANY. This company had been operating in Chicago from 1933 to 2016, when it was taken over by another elevator company. Hopkins Illinois modernized, repaired, installed and provided parts for all makes of elevators. I spoke to Carol Hopkins Siemeon, who told me the company was first housed at 1325 East 47th Street and that the Hopkins family lived in an apartment above the shop, which was started by her father. Carol worked there for some time, and after her father passed away, she took over. At its peak, the company employed thirty-five, but by 2016, the staff was considerably reduced. It was certified as a woman-owned business, helpful when a project required such a business be used. They mainly serviced small businesses but at one time had a contract to service elevators for the University of Chicago.

OPPOSITE Hopkins Illinois Elevator Co. 2001, 1950s, 2300s South Indiana. Lost.

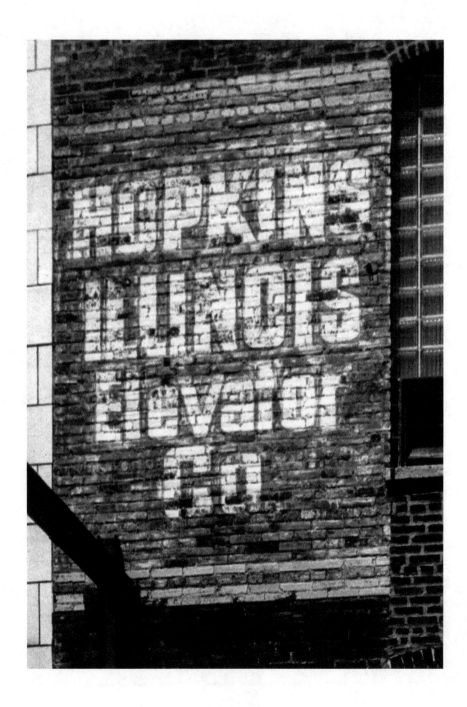

GOOD PRINTING, an ad for a printing, engraving and stationery store. The phone number indicates this ad was created no later than the mid-1920s. This wall had two ads. The one for Classic Soap is listed in the "For the Home" section.

BEST…IN THE POLISH WORLD. Although one cannot decipher the whole ad, it may refer to the *Polish Daily News*, the largest and oldest Polish newspaper in the United States. I spoke to the editor of the paper, Alicia Otap, who explained that there were many Polish newspapers early in the last century. This ad reappeared when the building next door was torn down, as evident from the rubble on the ground. I found a picture of this ad on the internet taken a little later, when all the rubble had been cleared away.

TOP Good Printing at Prices You Can Afford, Fancy Stationery, Engraving…Telephone Englewood 362, 1981, 1920s, 6416 South Cottage Grove. Lost.

BOTTOM Best…in the Polish World, 2011, 1920s, 1900s South Halsted. Lost.

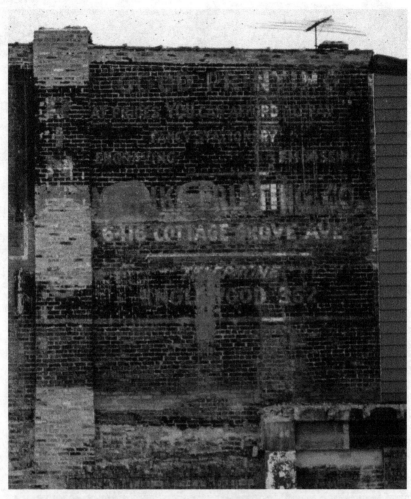

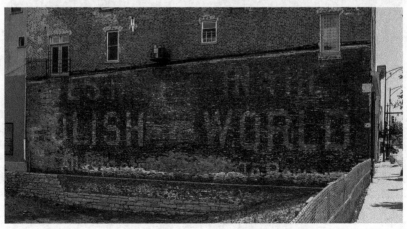

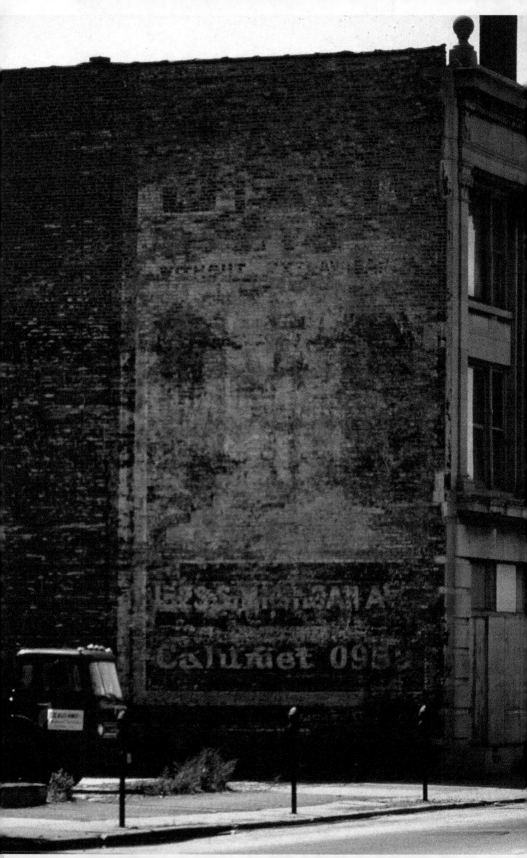

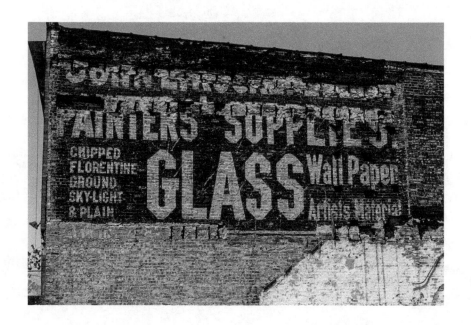

CALUMET 0952. The phone number is all that is left readable on this ad, located on Automobile Row. The four digits indicate an ad painted after 1925 or so. The style says 1920s to me.

GLASS, PAINTERS' SUPPLIES…. This ad appears to be one that is directed more to contractors than do-it-yourselfers.

OPPOSITE Calumet 0952, 1980, 1930s, 1529 South Michigan. Lost.

ABOVE Glass, Painter's Supplies, Wallpaper…, 2001, 1930s, 4900s South Cottage Grove. Lost.

THE WEST SIDE

The West Side is a large and ambiguously defined area. Looking at a current map of Chicago, one might define it as that area south of Interstate 90–94 and north of Interstate 55. Before these routes existed, however, people self-defined where they lived in terms of direction, or they referred to the community in which they lived. As noted, I have used my best judgment as to where to place each illustration.

NEWSPAPERS

THE CHICAGO SUNDAY TRIBUNE. The *Tribune* is one of the few newspapers in the United States that began publication in the mid-nineteenth century and has been continuously published ever since. Founded in 1847, its early editor, Joseph Medill, was a supporter and friend of Lincoln. The paper has a long reputation as conservative and was initially nativist, anti-Irish and anti-Catholic. The *Tribune*'s editorial policy also supported temperance. After the Civil War, Medill lost his position for some years and was less extreme when he returned. His many innovations included lowering the price of the daily paper from five cents to a penny. The paper was the first in the city to use colored pictures. The paper stayed in the family when Medill's son-in-law succeeded him as editor. Robert Patterson tackled political corruption, a fight in which the paper is still engaged. In 1910, Colonel Robert McCormick became editor, a position he held until his death in 1953. While innovative in some ways, such as bringing in advice columns and expanding the comics section (think *Little Orphan Annie*), McCormick also was very conservative and hated the New Deal and FDR. He assured everyone that the *Tribune* was the "World's Greatest Newspaper" and used the initials of that slogan for the *Tribune*'s radio station, WGN. In recent years, ownership has changed several times, and the current owners of the *Tribune* have sold its iconic Tribune Tower, now being converted into condos.

This ad declares the *Sunday Tribune* the "Seventh Day Wonder of the World." I do not look upon this as a modest statement. Above the *Tribune* ad, one can see an ad for pianos and the College of Music.

OPPOSITE The *Sunday Tribune*, Seventh Day Wonder of the World. At top: Pianos, College of Music, 1981, 1920s, Roosevelt Road and Harding. Lost.

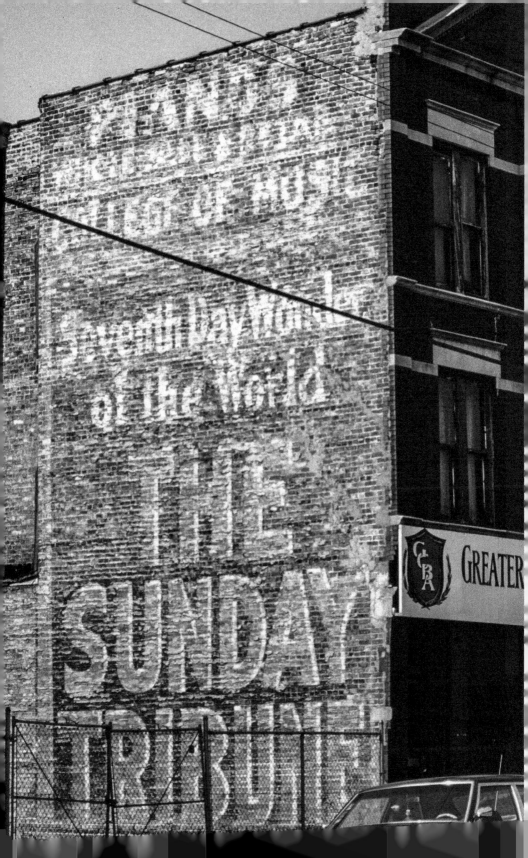

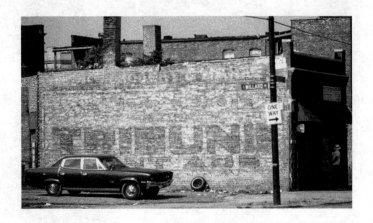

TRIBUNE WANT AD. This ad was found quite close to the first *Tribune* ad but is more modest.

CHICAGO DAILY NEWS. The *Daily News* was Chicago's premier afternoon paper. It was started in 1876 and was soon bought by Victor Lawson, who modernized the business management of the paper. It was one of the first papers to have a foreign news bureau and a column devoted to radio. Like the *Tribune*, it had its own radio station, WMAQ. In 1929, it built an art deco building now called Riverside Plaza, which borders the Chicago River at Madison Street. In 1930, it tinkered with an experimental TV station. It was the city's first penny paper and exceeded the *Tribune* in circulation until 1918. For many years, its most famous columnist was Mike Royko, who skewered many Chicagoans, especially politicians, and who eventually wrote for the *Chicago Sun-Times* and the *Chicago Tribune*. Sadly, the *Daily News* ceased publication in 1978 after a number of ownership changes. I still have in my basement a copy of its last issue, published on March 4, 1978. Many identical copies of this wall ad were created in many locations in Chicago, encouraging readers to "Read and Use the Daily News Want Ads."

ABOVE *Tribune* Want Ad, 1981, 1920s, Roosevelt Road and Millard. Lost.

OPPOSITE Read and Use the Daily News Want Ads, 1980, 1930s, near 24th and Western. Trace remaining.

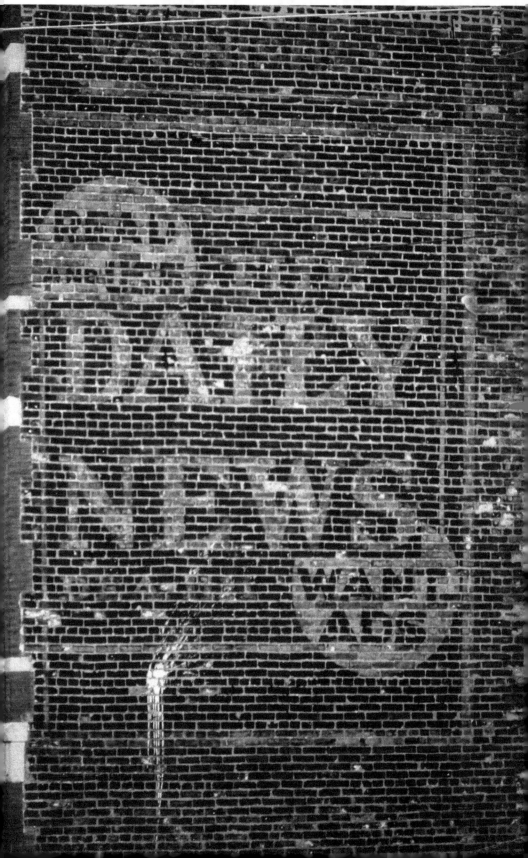

AUTO-RELATED

AGNI. This ad was on a wall facing the parking lot of an auto repair shop. If this product was not auto-related, it was auto-adjacent, as one saw it immediately upon entering the lot. The wall advertised various services, including Hydraulic Air Pressure, the new system that replaced inflating your tires with a hand pump. The shop, whose name I do not remember—although I frequently left my car there—was most unusual. Its staff of mechanics was a model of diversity before its day: white, African American, Hispanic, both male and female. The office was the enormous hood of a giant yellow Cadillac convertible. That is where the phone sat and the paperwork was done.

CHAMPION SPARK PLUGS. This product has more than a one-hundred-year history. The company was started in 1907, and Henry Ford used these spark plugs in his Model-T in 1908. They have been made to fit a wide variety of combustion engines. This ad is on West Chicago Avenue, a borderline location, so it was placed in the West Side rather than North Side.

TOP Expert Greasing, Hydraulic Air Pressure, Agni, 1984, 1930s, Ogden and Sawyer. Lost.

BOTTOM Champion, 1998, 1960s, 1800s West Chicago.

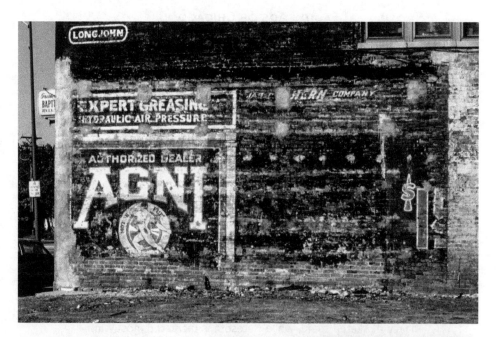

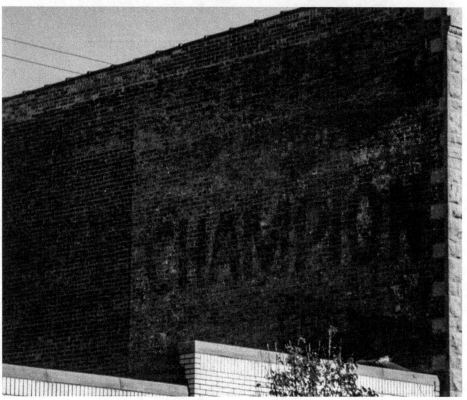

FOODS

CERESOTA FLOUR. A number of ads for Ceresota were created in Chicago, and another is pictured in the "Food" section of the chapter on the North Side. Ceresota is an old product first packaged with this label in 1891. It was formulated as a high-protein flour produced from winter wheat grown in Kansas. This flour and another brand, Heckers, have been owned for many years by the Uhlmann family in Kansas City. Heckers was started in the 1840s in New York State and is mainly marketed there, while Ceresota is marketed mostly in the Chicago area. The ad was rather faded when found, so what one makes of the flour is unclear. One of the Hecker brothers is reported as being the first person to create self-rising flour.

GOLDEN LOAF. Must be a bread. Sounds like a soft white bread now gone out of style. It also mentions "Royalty Flour" and has other words that appear isolated and whose meaning is not clear. This ad, like "Champion Spark Plugs," is in a borderline location, so I placed it in the West Side rather than the North Side.

TOP Ceresota Flour You Can Make..., 1989, 1930s, Ogden west of Kedzie. Lost.

BOTTOM Golden Loaf and Royalty Flour, 1981, 1930s, Western and Kinzie.

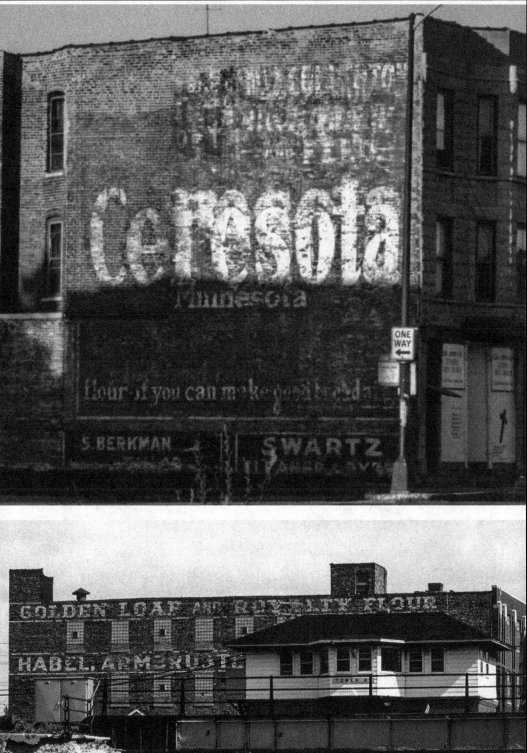

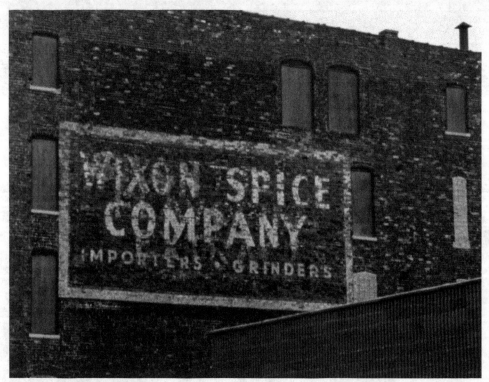

GOLD MEDAL FLOUR. This is another food product that has been available to Americans for a long time. The name was applied to this flour produced by the Washburn-Crosby Company when it won the gold medal at the Millers International Exhibition in Cincinnati in 1880. In the mid-1850s, Cadwallader Washburn bought an earlier company founded in Minneapolis. In 1878, the Washburn-Crosby factory suffered a severe explosion, not a rare event in the milling industry. As a result, the owners developed a safer way to produce flour. They stayed in business under this name until 1928, when Washburn-Crosby merged with twenty-eight other mills to create General Mills Inc.

GENERAL MILLS is a giant in the food industry. When I researched this book, it ranked 181st of the 500 largest American corporations and was the third-largest consumer products company. Its product lines include Betty Crocker, Yoplait, Pillsbury, Old El Paso, Häagen Dazs, Cheerios, Coco Puffs and about a hundred other brands. At one time, it owned the Red Lobster and Olive Garden Restaurants. The electronics division developed the Alvin submersible used to discover the *Titanic*.

WIXON SPICE COMPANY. Driving east on 18th Street near Dearborn Street in the summer of 1981, with the window open, I caught a whiff of the most wonderful aroma. Because this was an industrial area, it was hardly the type of smell one anticipated. The internet and a phone directory produce no evidence that this company still exists, or at least not in that location. If I inhale deeply, I can still smell the aroma.

TOP Gold Medal (Flour), 1981, 1930s, Southwest corner Ogden/Rockwell.

BOTTOM Wixon Spice Company, Importers, Grinders, 1981, 1950s, Near 16th and Dearborn. Lost.

BEVERAGES

COCA-COLA. Early Coca-Cola wall ads are everywhere in this country, and I have included several in this book. Old Coke ads have such appeal that in some places they have been restored so that they can no longer be considered fading ads. Coke was first sold in 1886 for five cents. The secret formula was first developed by John Pemberton, whose recipe included extracts from coca leaves, kola nuts and carbonated water. It was marketed initially as a patent medicine that, like many other products of the time, was purported to cure many diseases, including morphine addiction, indigestion, nerve disorders, headache and impotence, to name a few. Pemberton himself apparently had a morphine problem after a Civil War injury.

Coca-Cola reduced its coca content shortly after initial production until 1903, when fresh coca leaf was no longer used at all and substituted with spent leaves. For many years, Coke has contained a cocaine-free coca leaf extract. Some early ads contain the words "relieves fatigue" in addition to "refreshing" and "delicious," words that are still used. I suspect the "relieves fatigue" claim was used before the formula change in 1903, when it was still regarded as a patent medicine. After the passage of the federal Pure Food and Drug Act early in the twentieth century, the sale of patent medicines decreased by one third.

Coca-Cola's own website indicates that in 1913, almost $260,000 was spent on painted wall ads. No figures are given for earlier or later years. We know, of course, that the company has advertised heavily in many media during the course of its existence.

OPPOSITE Drink Coca-Cola, Delicious and Refreshing, Relieves Fatigue, Sold Everywhere. At top: Drugs, Candies, Cigars, 1981, before 1910, 4110 West Roosevelt. Lost.

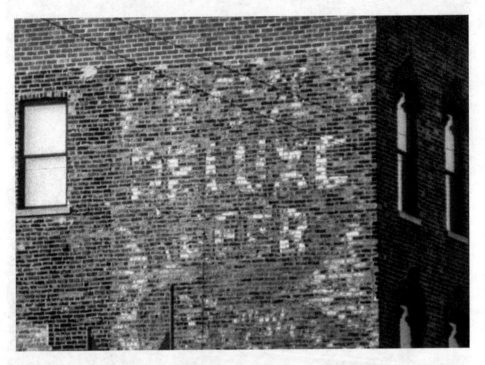

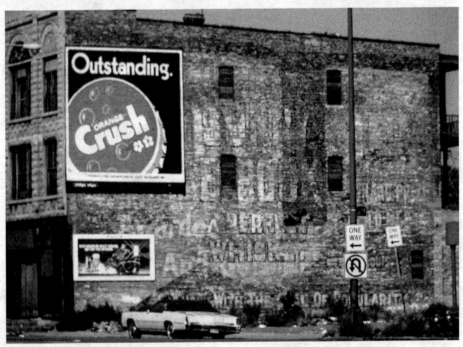

FOX DELUXE BEER. This beer was distributed primarily in Chicago and surrounding areas. Unlike many other breweries, Fox Deluxe was started after Prohibition was repealed in 1933. The company was owned by the nine Fox brothers, who reputedly bought a brewery from Al Capone. The family had been in the meat business. After a period of expansion and buying breweries in other cities, it became the thirteenth-largest brewing company in the United States. After a number of years, the company closed when it, like many mid-sized breweries, could no longer compete with major U.S. breweries.

SUNNY BROOK WHISKEY. This company was one of many whiskey and bourbon companies in Louisville and other areas of Kentucky. In 1891, a Chicago company purchased the Sunny Brook Distilling Company. Sunny Brook was made in the same factory from then until 1975, when the factory was razed. In the 1980s, it was bought by another distiller. The brand is now owned by Jim Beam. For many years, its slogan was "The Pure Food Whiskey."

TOP Fox Deluxe Beer, 1998, 1950s, Grand east of Ogden.

BOTTOM Sunny Brook Whiskey with the Seal of Popularity, 1981, 1930s, 3500 block West Ogden. Trace remaining.

FOR THE HOME

GOLD DUST THE BUSY CLEANER. The N.K. Fairbanks Manufacturing Company developed two well-known cleaning products in the late 1880s: Gold Dust Washing Powder and Gold Dust Scouring Soap. These were the first all-purpose cleaning agents for sale in the country. They proved to be better than previous products. The formula was developed in Chicago and used vegetable oils, mostly cottonseed oil. Success was also predicated on lower cost. These products were distributed mostly in the Midwest. Lever Brothers purchased the company in 1930.

The Fairbanks Company's advertising was famous for picturing the Gold Dust Twins, Goldie and Dustie. The twins were black, the ads black and white with an orange background. The twins were one of the earliest brand-driven trademarks in American advertising. They were often pictured with one washing and the other drying dishes. Some ads stated: "Let your twins do the work." This trademark was used for about sixty years, but the stereotyping of African Americans contributed eventually to a loss of sales. The advent of detergent soaps also negatively affected sales.

OPPOSITE Gold Dust the Busy Cleaner, 1981, 1930s, Roosevelt west of Kenton. Lost.

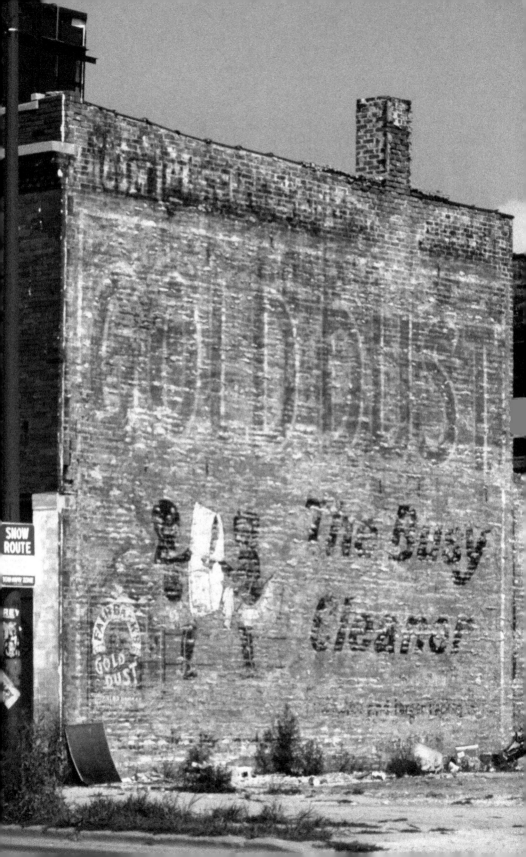

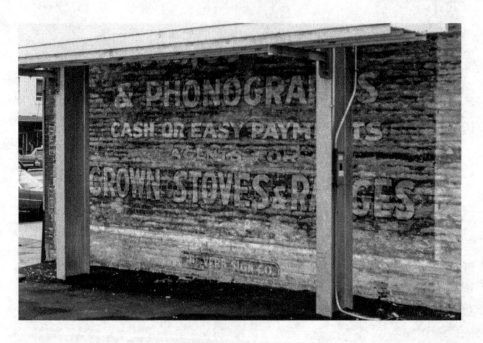

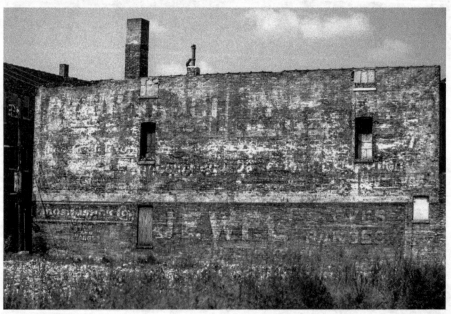

PHONOGRAPHS, CROWN STOVES. It appears this ad was on the side of a building that sold household appliances and equipment. The Crown Stove Works made gas stoves for the home. This ad was found slightly west of the Chicago city limits, in the suburb of Cicero. The factory was located about a mile and a half from the building with the ad. The ad alerts prospective customers that they can pay by cash or "carry" credit, in essence, pay in installments with interest.

JEWEL RANGES. This brand was one of several manufactured by the Detroit Michigan Stove Company. The company made stoves for home and industry, such as restaurants, clubs and hotels. It was founded in the 1860s and made stoves and ranges under several corporate names. Because of the iron deposits in northern Michigan, the state became a leader in iron-made products. Michigan was at one time known as the "Stove Capital of the World." This ad also promotes "cash or carry" payments, a method of payment that became obsolete with the advent of the credit card.

TOP Phonographs, Cash or Carry Payments, Crown Stoves and Ranges, 1981, 1930s, Cermak west of Cicero Avenue in Cicero, a Chicago suburb.

BOTTOM Stoves....Jewel Ranges, 1981, 1930s, 1900 block West Roosevelt.

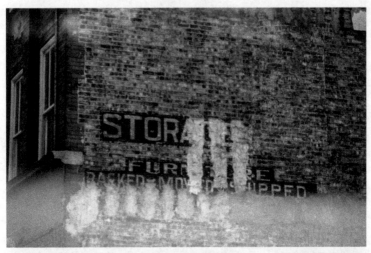

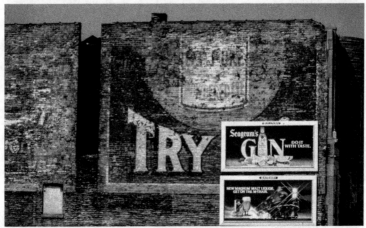

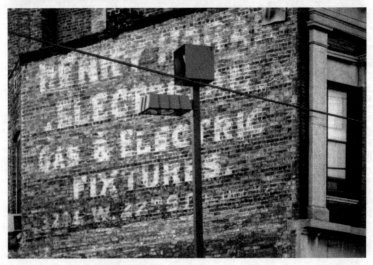

FURNITURE PACKED, MOVED, SHIPPED. To my best recollection, this ad was found on the West Side, although I failed to note the location. Let this be a lesson to the fading ad hunter. Make sure you make *all* the documentation you need.

TRY...POWDERED LYE. This ad is unusual for being on the front of a building. Furthermore, it appears that the third floor of the building was removed after the ad was painted. The most likely cause was a fire on the third floor. Then there is the question of how one reads the ad. The word "pure" is decipherable.

HENRY HARAK. Harak advertises himself as an electrician who works on both gas and electric fixtures. This information places the ad at the time the country was transitioning from gas to electrical lighting. My house was built in 1904 and has gas lines through which the first electric wires were threaded. Harak's business must have been successful enough to merit a good-sized ad.

TOP Storage, Furniture Packed, Moved, and Shipped, 1984, 1940s. Location unknown.

MIDDLE Try...Powdered Lye, 1981, 1930s, about 1400 block West Roosevelt. Lost.

BOTTOM Henry Harak Electrician, Gas and Electric Fixtures, 1989, 1910s, Cermak west of Kedzie. Lost.

CLOTHING

This section lists seven ads for clothing or clothes making. All advertise local companies or stores that do not rise to the level of inclusion in Wikipedia, The Encyclopedia of Chicago or lists of Illinois corporations. My comments on them are therefore brief. What I believe is the oldest ad in this book is in this section.

CLOTHING &…. The ad was in the process of being painted over when I discovered it. So I shot what was there. A few days later, I took another picture. This time, the wall was painted over completely.

TOP Clothing and…, 1981, 1910s or earlier, Archer two blocks east of Damen. Painted over in 1981.

BOTTOM Clothing and…, Painted over.

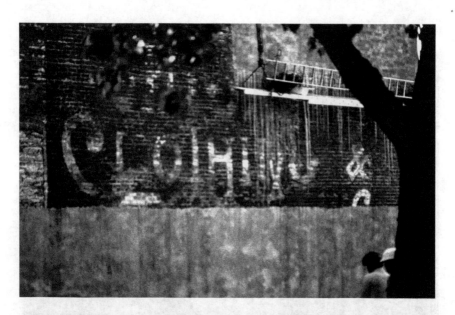

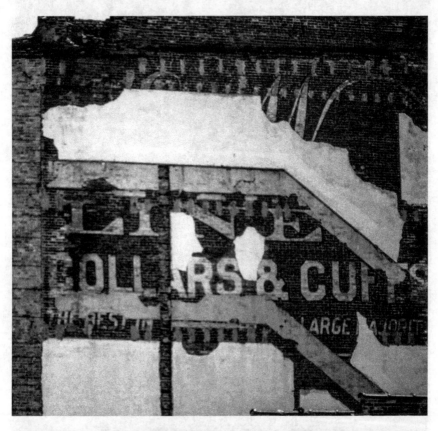

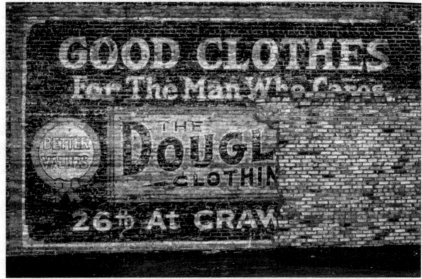

COLLARS AND CUFFS. An early twentieth-century ad in which only some of the words are available. We can only wonder what it was "the best in."

GOOD CLOTHES. This men's store seems to appeal to men who wish to better themselves. They are pitching "the man who cares." It is the only clothing ad I found that mentions a brand of clothes. This was, I believe, an American brand. There is a current European brand of the same name.

TOP Collars and Cuffs, The Best in...Majority, Large, 1980, 1910s or earlier, Washington east of Ogden. Lost.

BOTTOM Good Clothes for the Man Who Cares, Better Values, Douglas Clothes, 1981, 1920s, Cermak west of Cicero Ave. in Cicero, a Chicago suburb.

DRESSMAKING AND FAMILY SEWING. No doubt this was a local shop.

CUFFS. I believe this ad is the oldest of all the ads in this book. From the style of lettering, it could have painted before the turn of the twentieth century. It is much obscured by the plaster remaining when the adjoining building was torn down. It mentions the Morris Clothing Company. A current men's store on the West Side by that name was not started until 1952.

TOP For Dressmaking and Family Sewing, 1981, 1930s, Western one or two blocks south of Polk. Lost.

BOTTOM Cuffs...Morris Clothing Co., 1980, 1890s, Loomis and Archer. Lost.

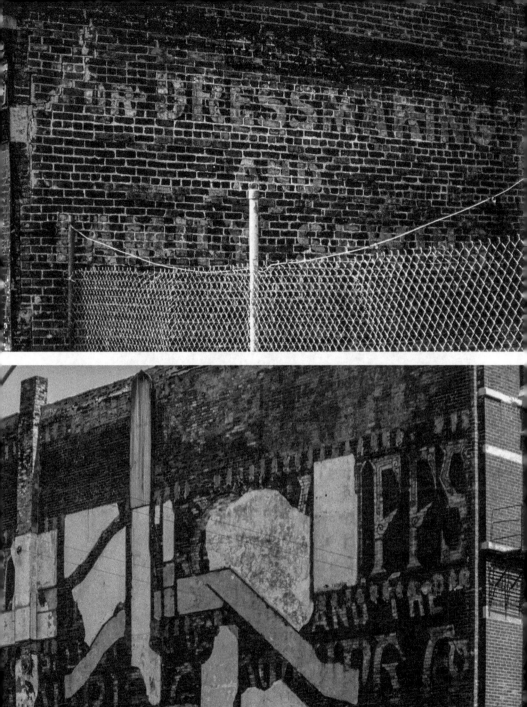
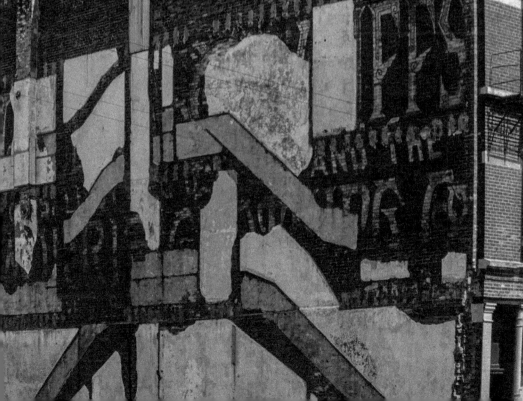

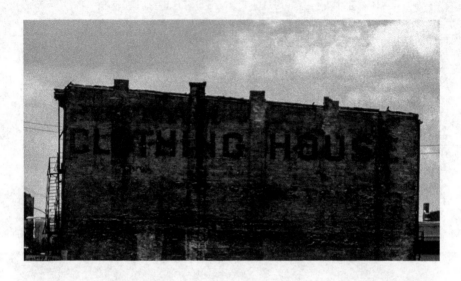

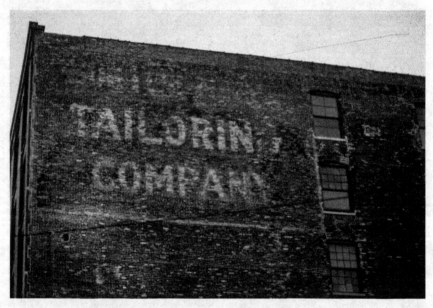

CLOTHING HOUSE. Just as some manufacturing companies were called "works," some retailers were called "house." Today, one is more likely to see a business called "the home of...."

TAILORING. Tailors made and repaired suits and coats. They made the whole thing, not just parts to be assembled down the line.

TOP Clothing House, 1980, 1920s, two blocks west of Madison and Halsted.

BOTTOM Tailoring Co., 1989, 1930s, Desplains and Harrison.

PATENT MEDICINE

HAMLIN'S WIZARD OIL. This was one of many bottled concoctions purported to cure just about every ailment known to humankind. While this ad claims it cures "Neuralgia, Rheumatism, and All Other Pains," some company ads made more specific claims as cures for pneumonia, cancer, dysplasia, earache, toothache, headache and hydrophobia. Hamlin claims for his oil, "There is no sore it will not heal." He first produced Wizard Oil in Chicago in 1861. John Austin Hamlin, a former magician, and his brother first bottled Wizard Oil for rheumatic and muscle pain. It was formulated with over 50 percent alcohol plus camphor, chloroform, sassafras, cloves and turpentine (egad!) for internal and external use. It was sold in part at traveling medicine shows in the Midwest. Two early hucksters of the oil are reported to be the writer James Whitcomb Riley and the singer-composer Paul Dresser, both Hoosiers. Carl Sandberg included two versions of a "Wizard Oil" song in his 1927 *American Songbook*. There is another ad above Wizard Oil.

FLETCHER'S CASTORIA. Castoria engaged in one of the most successful early advertising campaigns in the United States in the late nineteenth and early twentieth centuries. Its ads were everywhere. The product was first made in 1868, but in 1871, the rights to make it were obtained by C.H. Fletcher. It started as a children's stomachache remedy. At the time of my research for this book, I discovered that it is still made as "Fletcher's Laxative." Like many companies begun long ago, Fletcher's has had several owners.

TOP Wizard Oil, Cures Neuralgia. Rheumatism, and All Other Pains, 1981, 1910s, California north of Polk. Lost.

BOTTOM Try...Chas. H. Fletcher's Castoria, 1981, 1930s, 4500 block West Madison.

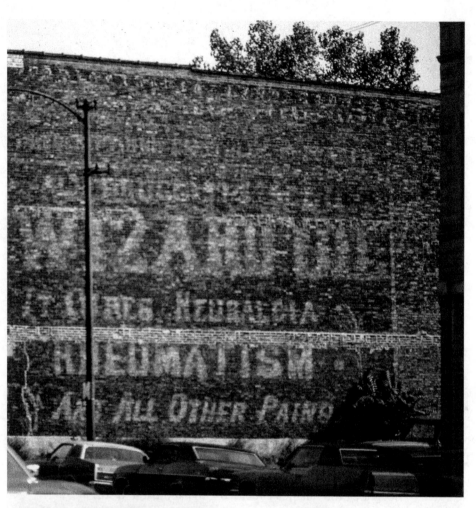

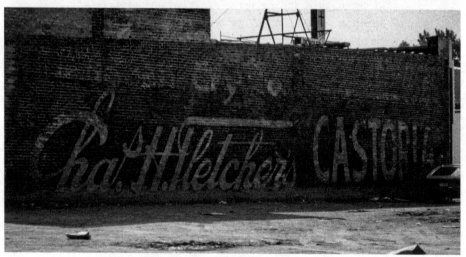

TOBACCO

BULL DURHAM SMOKING TOBACCO. Like Fletcher's Castoria and Coca-Cola, this product was heavily advertised in various media throughout the world. It is possible that more money was spent on Bull Durham ads during its heyday than ads for any other product. Their campaigns influenced modern advertising and proved that saturating various media with ads could promote sales growth. The company was

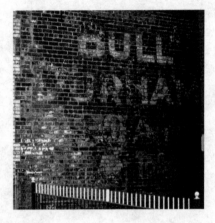

started in the 1850s and was a hit with soldiers in the Civil War. Because it was made in Durham, North Carolina, one wonders how widely available it was in the North. Over the decades, the company had many owners. By 1883, it was successful enough to have been sold for $300,000. Its biggest period of growth and advertising was the end of the 1800s and first half of the 1900s. Ultimately, Bull Durham was bought by the American Tobacco Company. Later, tastes in smoking changed, and rolling one's own became less popular. Production stopped in August 1988. I can still picture my father-in-law pouring tobacco out of a bag with drawstring closures onto cigarette paper, rolling up the cigarette and sealing it with a lick of the tongue.

INSET Bull Durham Tobacco, 1980, 1930s, on 24th first block east of Western, Lost.

OPPOSITE Bull Durham Smoking Tobacco, The Standard of the World (also: Fish and Oysters), 1981, 1920s, Roosevelt and Christiana.

OTHER ADS

HIGH GRADE AND 134 STATE…68 AND 70 MAD(ISON). These two ads are part of the ad illustrating the fifth type of ad described in the Introduction. We do not know to what "High Grade" refers. Note also that the street addresses are not designated as North or South State or East or West Madison. This indicates that the ad was painted before 1908, when all Chicago addresses were standardized in the system used to this day.

MARSHALL SQUARE BALLROOM. This space was above a tavern on the first floor, no doubt a convenient arrangement. Marshall Square is the local name for an area in the southeast corner of South Lawndale, one of Chicago's seventy-seven community areas. The picture shows a formally dressed couple dancing. As the ad says, the ballroom is "For Rent for All Occasions." In earlier decades, the area was home to many Eastern European immigrants, today to Mexican Americans.

TOP High Grade (whole ad is in Introduction), 1982, before 1910, Washington and Ogden. Painted over in 1982.

MIDDLE 134 State, 68 and 70 Madison (whole ad is in Introduction), 1982, before 1910, Washington and Ogden. Painted over in 1982.

BOTTOM Marshall Square Ballroom for Rent for All Occasions, 1981, 1940s, 3115 West Cermak. Lost.

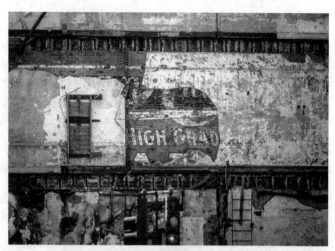

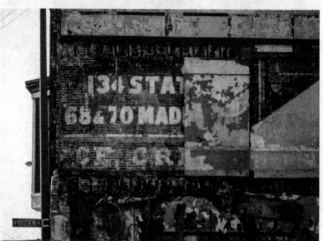

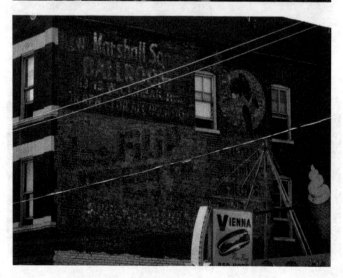

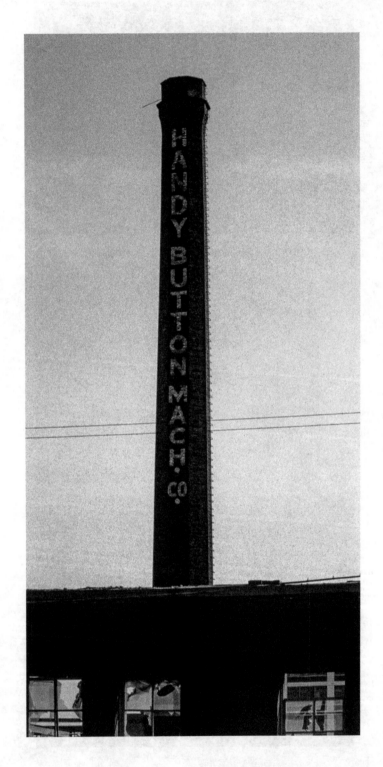

HANDY BUTTON MACHINE COMPANY. The ad on the smokestack and an ad on a wall were photographed in 1982, when the factory was being torn down. This family-owned company was founded in 1898 and still exists under the name the Handy Kerwin Group. I had the opportunity to speak with Michael Baritz, great-grandson of Morris Perlman, the founder of the company. The company originally made bottle caps but built its reputation making equipment used by other companies to make upholstered buttons for clothes, couches, chairs and the like. The company no longer manufactures the various products that its two divisions sell. Manufacturing is outsourced to American and overseas producers. Among the products it currently sells are twines, grommets, mattress hardware and some button equipment. They are now a smaller company than in former years. Before I started this project, I had never given a thought to how the cloth covering the buttons on my couch came to be there.

OPPOSITE Handy Button Machine Co. 1982, 1930s, Cermak and Rockwell. Building torn down in 1982.

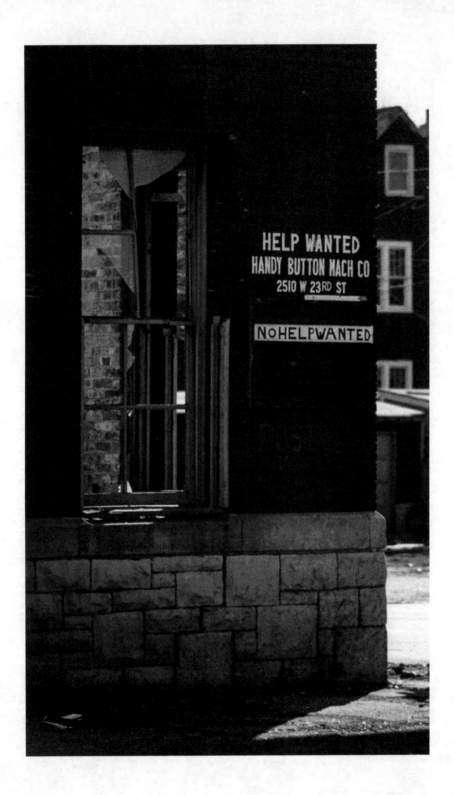

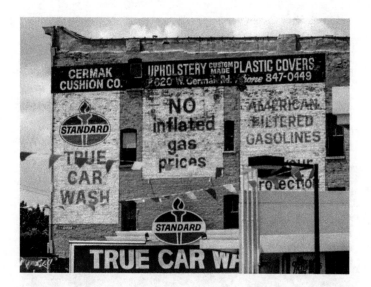

HELP WANTED. Here is an ad that was still in view at a corner of the Handy Button Machine Company building not yet entirely demolished. Aside from the contradiction of "Help Wanted" at the top and "No Help Wanted" at the bottom is the irony of either ad remaining on a building under demolition. Baritz told me that the building, which was not the first the company occupied, had originally been a carriage works. The company is now located in a suburb.

NO INFLATED GAS PRICES. This wall ad was really not so fading when I photographed it in 1980. It may refer to gas prices that had risen sharply after the Arab-Israeli war in 1973. The consortium of Arab oil companies (OPEC) had for a time curtailed oil imports to the United States, which drove up prices. This wall faced a Standard Oil Station. Standard Oil no longer exists by that name.

OPPOSITE Handy Button Machine Co., Post No Bills, Help Wanted, No Help Wanted. 1982, 1980s, Cermak and Rockwell. Building torn down in 1982.

ABOVE Standard, No Inflated Gas Prices, 1980, 1970s, On Cermak but cross street not recorded.

INSURANCE? I guess it is asking if you have any.

DEPARTMENT OF WELFARE. This building was the location of the Rehabilitation Department of the City of Chicago. It contains a picture of Richard J. Daley, the father of our more recent Mayor Daley. As the city reduced many services, or spun them off, this was one that went. The city once had a Department of Welfare, which included a Children's Division. This service was rolled into the State of Illinois Department of Children's and Family Services in 1964. The Rehabilitation Department may have disappeared around that time.

ABOVE Insurance? 1981, 1930s, Cermak two blocks east of Cicero.

RIGHT Department of Welfare, Rehabilitation Center 1981, 1960s, on West Grand. Exact location not recorded.

3
THE LOOP

I n the original sense, the Loop was defined as the area bounded by the elevated train tracks that loop around part of the downtown area, from Lake Street on the north to Van Buren on the south, and from Wabash on the east to Wells on the west. In general usage, the designation includes two or three blocks beyond these boundaries. The broader area would be described as "downtown." The terms "the Loop" and "downtown" are now used interchangeably.

The ads in the Loop differ somewhat from those in other areas. Here I found neither automobile ads nor ads for local foods such as flour or bread. There are ads for several department stores but not for Marshall Field or Carson Pirie Scott stores. There are no liquor or beer ads, although the area offered many places to imbibe. No ads for alcohol would have been placed anywhere during Prohibition. Since there were consistently bigger and taller buildings in the Loop compared to the outlying shopping areas, some downtown ads are larger and higher up on the walls. And a large percent of Loop buildings had lots of windows, whether on floors used for selling or for office space. This precluded the painting of ads on such structures.

ENTERTAINMENT, DEPARTMENT STORES AND MUSIC

THE CHICAGO THEATER. A very large ad appears on the south wall of the theater. This theater was the flagship of the Balaban and Katz chain, which at its peak included twenty-eight theaters in Chicago and over one hundred in the Midwest. It was built in the Neo-Baroque French Revival Style in 1917 at a cost of over $50 million in today's dollars. It is both a Chicago Landmark building and listed in the National Register of Historic Places. At the time it was built, it was the largest and costliest theater in existence. Originally, it had a full orchestra, a large organ and air conditioning. You would go there for first-rate films, live entertainment and bands. The theater suffered from the drop in movie attendance in the 1960s and 1970s and closed briefly in 1985. It reopened in 1986 with a Frank Sinatra concert. It is now owned by the Madison Square Garden Corporation and presents various types of live entertainment. If you have seen the Paris Opera, you would find the grand staircase familiar, rising as it does from an ornate five-story lobby.

THE BOSTON STORE. The chain is described in the "For the Home" section of the chapter on the South Side. The ad sits high on a large wall.

TOP Chicago Theater, 2004, 1930s, in alley north of Randolph and State. Present.

BOTTOM Boston Store, 2004, 1920s, south of Madison near Dearborn. Lost.

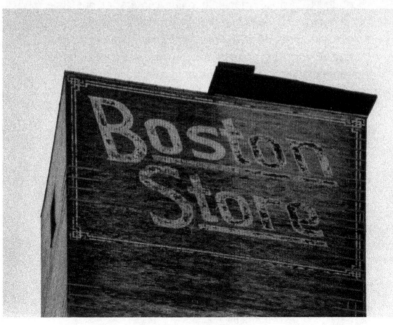

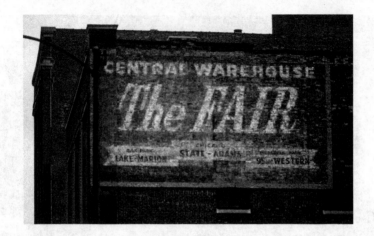

CENTRAL WAREHOUSE—THE FAIR STORE. The Fair was one of several department stores along State Street. Started in about 1875, it appealed to the thrifty and lower-income shopper. It took its name from selling goods at "fair" prices and operated at its opening on a cash-only basis. By 1897, the Fair had built a large twelve-story building and expanded to stores in local shopping centers. At one time, the company employed five thousand employees. After 1925, ownership changed first to the Kresge chain (later Kmart) and then to Montgomery Ward, which discontinued the Fair name. Montgomery Ward is now consigned to history, and the Fair building was torn down in 1984. Most Loop department stores had warehouses in locations separate from their retail stores.

RETAIL SHOPS AND OFFICES. The top part of this ad is overlaid, obscuring which building is being advertised. It is what the Loop was all about—retail and offices.

ABOVE Central Warehouse, The Fair, 1981, 1930s, State and Adams. Lost.

OPPOSITE Retail Shops and Offices, 2004, 1930s, State between Monroe and Adams. Lost.

THIS IS THE
NORTH
AMERICAN
BUILDING

WHERE LEADERS IN
NATIONALLY KNOWN
MERCHANDISING LINES
MAINTAIN THEIR OFFICES
AND SHOW ROOMS

RETAIL
SHOPS
AND OFFICES

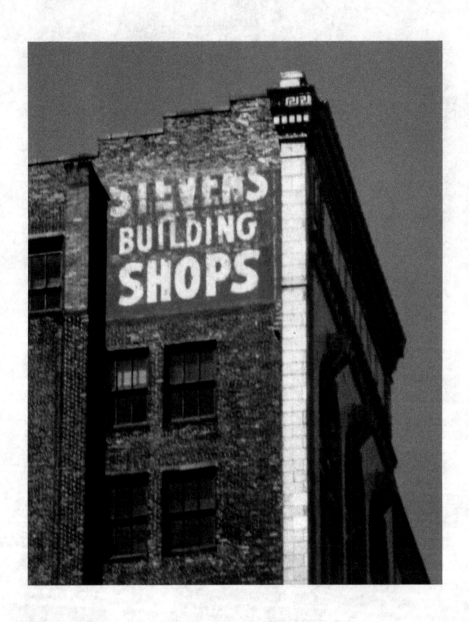

STEVENS BUILDING SHOPS. The building was built in 1912 and was unusual because it had two merchandising zones. The basement and first six stories were occupied by the Charles A. Stevens and Brothers Department Store. The twelve stories above the Stevens store were devoted to specialty stores and services primarily catering to women, such as clothing stores and the offices of organizations. The building fronted State Street, and a block-long arcade went through to Wabash. The architect was Daniel A. Burnham, famous for his 1909 "Plan for Chicago" and for spearheading the Columbian Exposition of 1893. The building is still standing. Many cities built arcades during this period to admit more light into sales areas and attract customers with impressive displays of varieties of goods in various shop windows. One of Chicago's last arcades was only recently torn down. I did not locate this ad, but the name of the building can still be seen at the top of the south side of the building but is not complete and is not pictured here.

OPPOSITE Stevens Building Shops, 1997, 1950s, Wabash and Madison. Lost.

LYON AND HEALY. They advertised "Everything Known in Music," and they meant it. Lyon and Healy made musical instruments in their own factory on the West Side, which is still making harps today. They sold recordings, phonographs, sheet music and antique instruments and had many studios for music lessons. In the 1890s, the company made over 100,000 instruments of various kinds, although today harps are its only product. The company was started in 1864 and made its first harps in 1889; Lyon and Healy manufactures the large majority of harps in use today. By 1900, it also was one of the world's largest music publishers. As market forces changed in 1981, Lyon and Healy closed the Loop store. Ownership had by then changed more than once.

KIMBALL PIANO COMPANY. Just as there was an automobile row, there also was a music row in Chicago. The area on South Wabash near Jackson and Van Buren boasts ads for Lyon and Healy, the Fischer Music Store and Kimball pianos. The W.W. Kimball Company was the world's largest piano and organ maker at the turn of the twentieth century. The company began in 1857 as a piano dealer, then assembled organs and made its own organs. Kimball stayed in the organ business until the 1940s and made the pipe organ for the Mormon Temple in Salt Lake City. After World War II, sales slipped, the company was eventually sold and manufacturing left Chicago. The last pianos were made by Kimball's successor company in 1996.

The Kimball ad was quite faded when I first saw it in 2004. By 2018, only the outlines of the last four letters, "BALL," were visible, and the piano player pictured at the bottom could no longer be seen at all.

TOP Lyon and Healy, Everything Known in Music, 2004, 1940s, Wabash south of Adams. Present.

BOTTOM Kimball, 2004, 1940s, Wabash south of Jackson. Trace remaining.

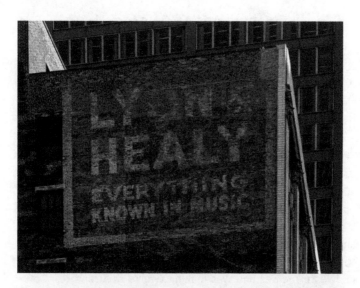

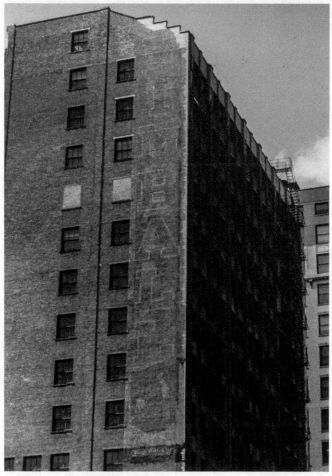

CLOTHING

M. SELZ AND CO. Morris Selz was not unlike many Jewish merchants who came to Chicago, grew his business and prospered. In 1854, Selz and Cohen was in the clothing business. By 1871, M. Selz and Co. was in wholesale shoes with a factory on Madison Street. Soon Selz had 300 employees and was making $1 million worth of shoes per year. By 1900, Selz, Schwab and Co. had 1,500 employees in various midwestern cities and was making twelve thousand pairs of shoes daily. Eventually, the Depression hit, and the company did not survive.

MAN IN FULL DRESS. By the time I found this ad, it was only a picture with no text, an ad no doubt for a formal wear store or a men's store that sold formal wear in the Loop.

TOP M. Selz & Co. Manufacturers of...Boots and Shoes, 1981, 1920s, Wabash near Madison. Lost.

BOTTOM Picture of Gentleman in Full Dress, 1989, 1940s, Randolph west of State. Lost.

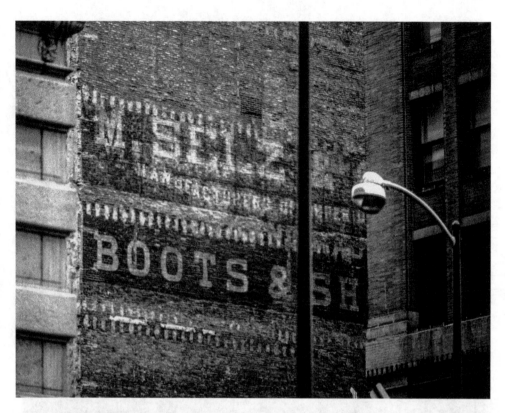

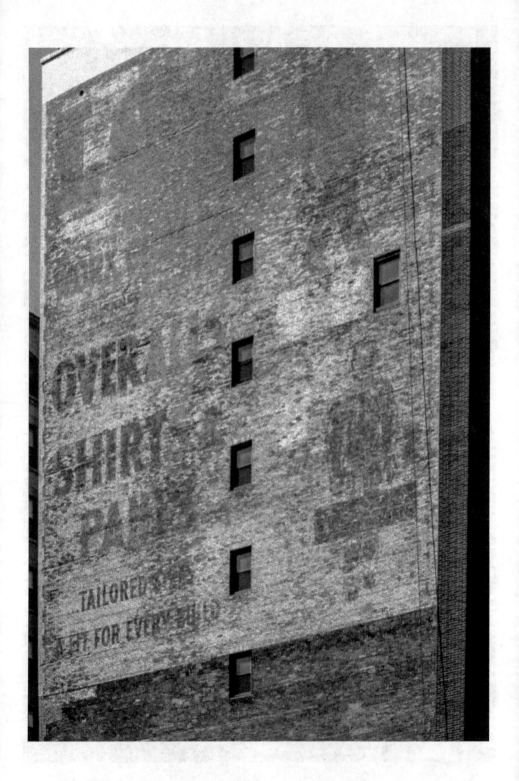

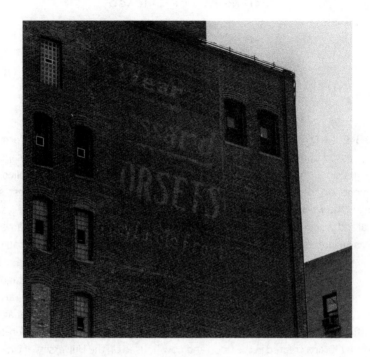

OVERALLS…. The ad notes that the advertiser makes "Shirts Pants Tailored...for Everyone." I doubt the overalls themselves were tailored. Like Levi's, overalls were made at the factory.

CORSETS. The viewer of this ad, high on a wall, is invited to "Wear B...ossard Corsets—They Do." This is the only ad I have found for ladies' foundations and was a relatively late ad, probably from the 1940s.

OPPOSITE Overalls, Shirts, Pants Tailored...for Everyone, 1997, 1960s, north of Polk Street Station. Lost.

ABOVE Wear B...ossard Corsets, They do..., 2004, 1940s, 1000 South Michigan. Present.

MANUFACTURING AND SERVICES

ADLAKE (ADAMS AND WESTLAKE, LTD.). Adlake is an old, formerly Chicago-based company whose origins date to 1857. It did business in Chicago for sixty years, until it moved to Elkhart, Indiana. It began making railroad supplies and equipment for the transportation industry and in time became the largest such supplier in the world. The company kept its initial focus while expanding into RVs and medical and grocery supplies. It does machining, foundry work, design, you name it. It even has an interest in supplying parts to those who wish to restore old railroad cars.

In 1874, companies run by Adams and Westlake merged to form Adlake. Each of these companies had been started earlier, and like many early and later Chicagoans, the founders originally came from out of town. Adams had worked for the railroad supply company Clark and Jessup in New York and came to Chicago to manage its local office. Another member of Clark and Jessup, John Crerar, is remembered for the Crerar Library, created in the Loop and now housed on the University of Chicago campus. There also was a Crerar, Adams and Co. Meanwhile, Westlake was born in Cornwall, Wales, came to the United States as an adolescent, and is best known for inventing the globe lamp, a railroad signaling lamp.

My acquaintance with Adlake came from one of its lesser-known products, box cameras. Adlake was an enterprising company that located niches in industry where making a new product would fill a need. For decades, I have collected vintage American-made cameras, including several models of Adlake box cameras made for glass-plate negatives. The niche that Adlake (and other companies) filled with this camera came about because George Eastman, the founder of Kodak, was having problems perfecting his recent invention, roll film. Adlake stepped into the gap and for five years (1897–1902) made cameras. When Eastman perfected an easily usable roll film, put it on the market and sold cameras for one dollar, Adlake's flirtation with camera manufacturing ended.

The ad with the Adlake company name is painted at the top of the west wall of the building that the company occupied in Chicago.

TOP Adlake, 1982, 1920s, Franklin and Ohio. Present.

BOTTOM The Adams and Westlake Company, 1982, 1920s, Franklin and Ohio. Present.

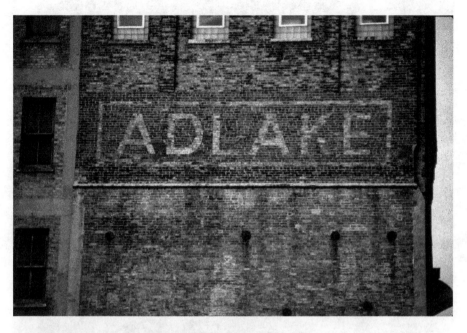

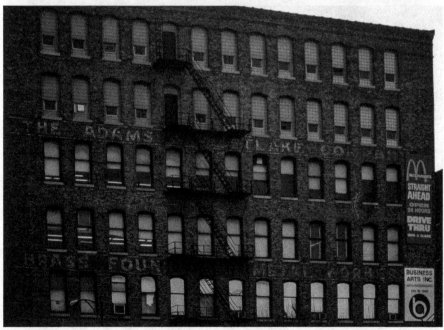

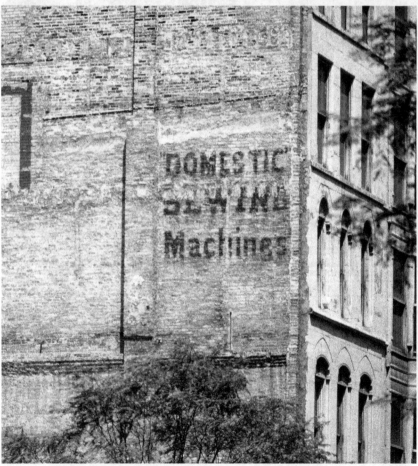

CHICAGO NATIONAL BANK. A bank that had a short life. It opened in 1900 and, before its collapse in the Depression in 1933, had become the Central Trust Company of Illinois. It constructed an imposing building with a façade and columns of Carrara marble designed by well-known Chicago architects Jenny and Mundie. Jenny was considered the father of the skyscraper, and many famous Chicago architects of the late nineteenth century were in his employ.

THE DOMESTIC SEWING MACHINE COMPANY. This company was begun in Ohio in 1869 and is one of the few companies founded so long ago that is still in existence. Later, it moved to New York, where sewing machine companies evolved from gun manufacturing companies, having learned to economize by using interchangeable parts. Domestic was smaller than the Singer Company but was independent until 1924, when it was bought by the White Sewing Machine Company and kept as a subsidiary.

TOP Chicago National Bank, 2004, 1920s. Seen from Wells looking east near Jackson.

BOTTOM Domestic Sewing Machines, 1981, 1930s, State north of Washington. Lost.

...RD & CO

AL PAPER
GRADE...

...RAPHICAL PUBLISHING CO.
PUBLISHERS OF
...APS AND ATLASES

WESTERN
...TO SALES CO.
...COND HAND C...
...D AND...

W. W. WELLM...

B 383766

ADS FOR THREE COMPANIES. The W. Ewroe Company was a paper seller although not necessarily a stationery store. It seems to have been a company that either made or distributed various types of paper for commercial use. Below this ad is another, for a map and atlas maker. The bottom ad can be found in the "Transportation" section in the South Side chapter.

LEFT W. Ewroe and Company, All Paper Grades, Geographical Publishing Co., Publisher of Maps and Atlases, 1988, 1930s, 1014 South Michigan. Obscured by construction fence. Future status?

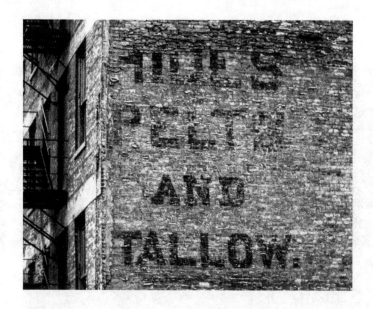

ADS FOR THREE MORE COMPANIES. The first advertises a printing company. The second is for a laundry and dry cleaners. And the third is for a maker of "Luxury Window Prisms." It seems odd to describe prisms as a luxury rather than necessity, as they were functional, thick glass circles or squares embedded in sidewalks to allow light to enter basements. American Luxury may have been the name of the company.

HIDES, PELTS AND TALLOW. Imagine my surprise at finding this ad in the West Loop in 1981. I was tempted to run right out to buy some tallow. The Chicago area was home to many industries dealing in products related to the famous Chicago stockyards. I recently learned that there is one remaining tannery in Chicago.

OPPOSITE National Printing, Chicago Cloth...Laundry..., American Luxury Window Prisms, Sidewalk and Prism Lights, 1981, 1920s, Wabash south of Congress. Lost.

ABOVE Hides Pelts Tallow, 1981, 1910s, Wells north of Madison. Lost.

NORTHWESTERN. The Chicago and North Western Railroad Company became one of the largest railroads in the United States. It was started in 1859 and grew and merged. Like other railroads, it declined with the expansion of air travel and super highways. It was sold to its employees in 1972 and bought in 1995 by Union Pacific. At one time, Northwestern had the largest freight yard in the world. Located west of Chicago, it could hold twenty thousand cars. Because of Chicago's hub position, Northwestern hauled a lot of agricultural products and had both suburban and long-distance passenger service. This ad is on the side of the south end of their Chicago terminal.

POLLY GRILL AND TEA ROOM. This restaurant had three locations in the Loop, including one at 17 North Wabash. This ad is on the side of a building that housed the restaurant. The operation was large enough to be listed in the 1920s and 1930s "Illinois Secretary of State's List of Certified Corporations."

TOP Northwestern, 1980, 1930s, Washington and Desplaines.

BOTTOM Polly Grill and Tea Room, 1981, 1930s, 17 North Wabash. Lost.

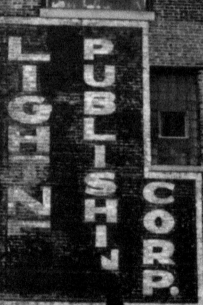

HOBBIES MAGAZINE. This magazine was published in Chicago by the Lightner Publishing Company. The ad was on the south side of its headquarters. Years ago, in our youth, my brother and I used to read *Hobbies* regularly.

STATE STREET OPPOSITE US. It would be nice to know what was there. It would also be nice to know where I took the picture, but I took it twenty years ago and failed to record where.

OPPOSITE *Hobbies* Magazine, S. Lightn(er) Publishing Corporation, 1997, 1950s, 11th and Michigan. Lost.

ABOVE State St. Opposite Us, 1998, 1950s. Location unknown.

4
THE NORTH SIDE

F or the purposes of this book, the North Side is that part of Chicago north of the Chicago River and extending to the north city limits and going west to that ill-defined boundary between the North and West Sides.

FOODS

MARIGOLD MARGARINE. The full ad for Marigold Margarine is cited as an ideal fading ad in the Introduction. It was so well preserved that it was not faded. Shown here is one portion of the ad. This ad created a small sensation when it suddenly appeared in 2007 after the building to the south was demolished. I was alerted to its unveiling by a phone call and rushed to see it. I was about to take a picture or two through the chain-link fence when the operator of a very big piece of earthmoving equipment stopped the engine and yelled over to me that I could get a better picture if I entered the earth-filled yard. He told me that lots of people were taking pictures of the ad. That was wonderful of him. Sadly, a short time later, a condo building rose on the lot, and only the left half of the ad is now visible. A picture of its current state can be found online.

Morris and Company of New York City made Marigold. An ad found online from 1915 shows what looks like an earlier style of packaging. The wall ad has the painting company's signature: Thomas Cusack and Company. Cusack was a pioneer in outdoor advertising. He grew his company, which also made billboards, until his ads could be found in one hundred countries. Perhaps sensing that the Depression was coming, he sold the company for $26 million in 1924. He was briefly a U.S. congressman.

OPPOSITE Marigold Margarine (close-up), 2007, 1920s, Lincoln one-half block north of Menominee. Right half of ad covered by new building.

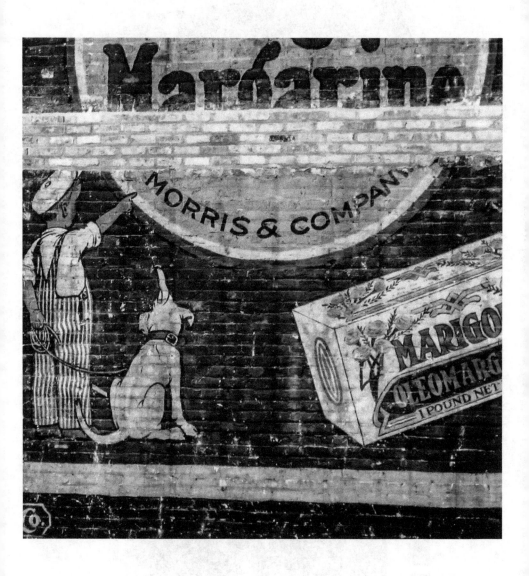

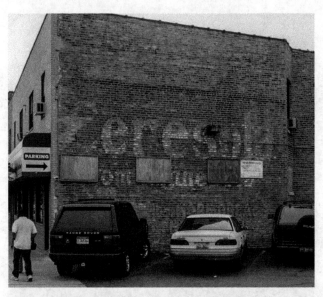

CERESOTA FLOUR. As noted earlier, this flour was heavily advertised. One ad appears in the West Side chapter. I have included here a picture of the whole ad and a separate one of the bottom half, which says "More Bread to the Barrel," partly obscured by cars. This dates the age to when flour was sold from a barrel so that you could buy whatever quantity you wanted. No five-, ten- or twenty-five-pound bags, please.

ROYAL BAKING POWDER. This company was originally founded by two brothers not long after the Civil War. They developed a new and widely accepted formula in the 1890s and moved the firm from Fort Wayne, Indiana, to New York. Their product became a bestseller. In 1929, Royal Baking and four other companies, including the Fleischmann Yeast Co., merged to form Standard Brands. About fifty years later, Royal Baking Powder was a Nabisco product. Nabisco is now a subsidiary of Mendelez International. But Royal Baking Powder, like the Energizer bunny, goes on and on.

TOP Ceresota, More Bread to the Barrel, 2004, 1920s, 1515 West Devon. Present.

MIDDLE Ceresota (close-up), 2004, 1920s, 1515 West Devon. Present.

BOTTOM Royal Baking Powder, 1999, 1930s, 360 West Chicago. Lost.

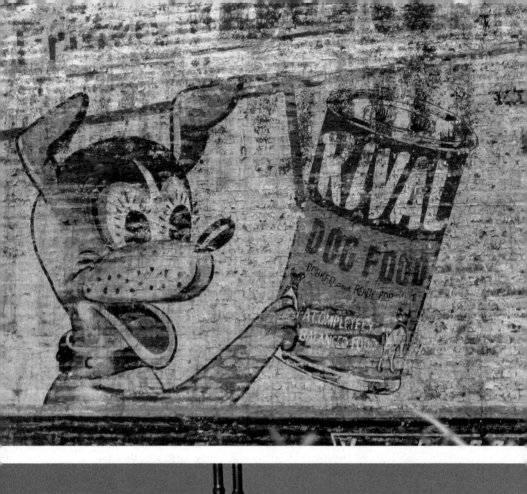

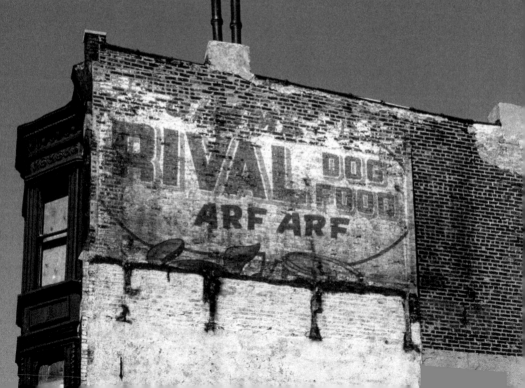

RIVAL DOG FOOD. Rival was one of the leading brands of dog food in the mid-twentieth century. It was one of the first to use cans and let buyers know it contained no horsemeat. It came on the market in 1923 but by the 1960s faced enormous competition as more dog owners bought dry dog food. Rival was apparently still made until a few years ago. Two major online dog food sellers did not list it when I prepared this book. The two ads pictured are quite similar, although only one has the dog barking, no doubt in anticipation of a hearty, horsemeat-free meal.

FREEMAN BROS. A local grocery store.

OPPOSITE, TOP Rival Dog Food, 2009, 1950s, California north of Peterson.

OPPOSITE, BOTTOM Rival Dog Food Arf Arf, 1990, 1950s, 1900 block North Halsted. Lost.

ABOVE Freeman Bros, Coffee, Teas, Groceries, 1992, 1930s, 2500 block Milwaukee.

QUAKER OATS. Another old food company with a Chicago history. A milling company in Chicago became part of a larger Chicago milling company that bought the Quaker Oats Milling Company of Ravenna, Ohio, in 1901 and became Quaker Oats. The company grew rapidly, bought Aunt Jemima Mills in 1925 and developed puffed rice and wheat and many other brands of cereals. It expanded into chemicals and dog food. Then came Gatorade.

MIDWEST WHOLESALE MEATS. The wall also advertised "Lassers Golden Oak," which may not be a food or drink.

TOP Quaker Oats, 1990, 1910s. North Side location not known.

BOTTOM Midwest Wholesale Meats, Lassers Golden Oak…, 1990, 1920s, between 2500–2600s Milwaukee.

DRINKS

COCA-COLA. A North Side version of the West Side ad. Now there are many new and heavily advertised drinks to "relieve fatigue."

CANADIAN ACE BEER. This brand is a Chicago beer that started out, ironically, as the Manhattan Brewery Company of Chicago. Its reputation had been tarnished by association during the 1920s and 1930s with some of Chicago's least upright citizens: Al Capone, Johnny Torrio and Frank Nitti. It stayed in business during Prohibition but after an up-and-down existence closed in 1968 when it could no longer compete with large national brands. Canadian Ace put up many wall ads in Chicago.

TOP Drink Coca-Cola, Delicious and Refreshing, Relieves Fatigue, Sold Everywhere, 2012, before 1910, 5200 block Broadway. Lost.

BOTTOM Take Some Home, Canadian Ace, 1986, 1950s, 600 block North Dearborn. Lost.

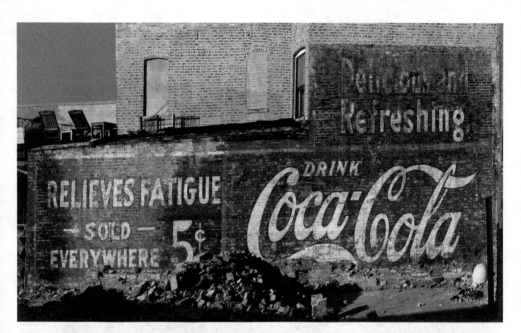

SCHLITZ. Schlitz is one of the best-known names in American beer. The company was originally founded in 1849 and was soon bought, in 1858, by Joseph Schlitz. After declining sales in the 1960s and 1970s, it was bought in 1982 by the Stroh Brewing Co., which was subsequently sold and resold, but the brand Schlitz is still very much alive today. At one time, Schlitz was the largest beer producer in the United States and often competed with Budweiser for first place. It relied heavily on railroads to speed distribution and created "tied" houses, taverns that agreed to sell Schlitz exclusively in exchange for favorable pricing. The following chapter has a picture of a half-globe emblazoned with the Schlitz name. Schlitz was known for its slogans, such as "The Beer That Made Milwaukee Famous" and "When You're Out of Schlitz, You're Out of Beer."

MISTLETOE GIN. One might not expect to spot a fading ad on upscale North Michigan Avenue, but this gin ad was located at 543 North Michigan. Within three years of my taking the picture, it was painted over. It may no longer have suited the ambiance, or perhaps the brand was no longer on the market. You can still see the border that surrounded the ad on the north side of this relatively small building.

TOP Schlitz, 1998, 1930s, northwest corner 21st and Rockwell. Lost.

BOTTOM Mistletoe Gin, 1981, 1930s, 543 North Michigan. Lost.

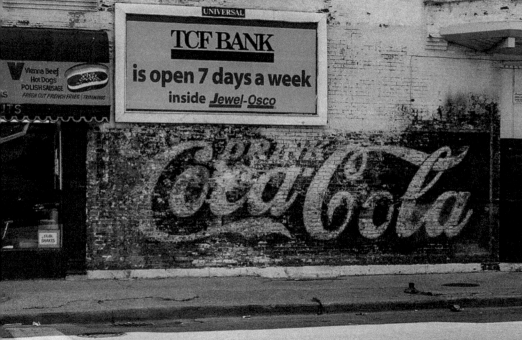

COCA-COLA—CIGARS. Another Coca-Cola ad, this time across the front of a drugstore. Were the cigars it sold "refreshing," and did they "relieve fatigue" as Coca-Cola ads in other places were prone to boast?

DRINK COCA-COLA. You get the picture of how ubiquitous these ads were.

TOP Drugs, Drink Coca-Cola, Cigars, 1997, 1930s, Schiller and Wells.

BOTTOM Drink Coca-Cola, 1998, 1930s, Damen and Diversey.

CLOTHING

MISFIT CLOTHING. I was startled to see this ad filling the entire height of a single-story building. The coloring and the shape of some of the lettering were unusual. Who bought this clothing? Mostly low-income shoppers or those with special clothing needs. The address of East Monroe suggests this ad was painted after 1908, but I suspect not much after. I consider this ad so unusual I include a full view and two close-ups.

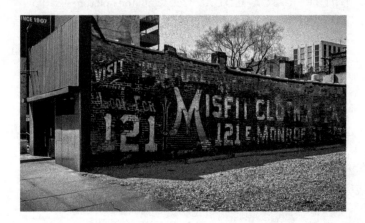

ABOVE Visit, Look for 121, Misfit Clothing, 121 East Monroe, 1994, before 1910, 1024 North Clark. Lost.

OPPOSITE Close-up Misfit Clothing Ad, 1994, before 1910, 1024 North Clark. Lost.

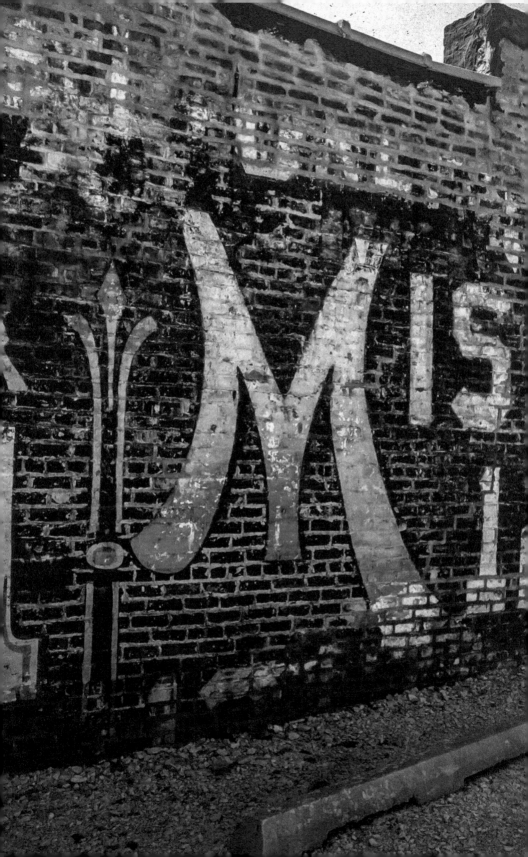

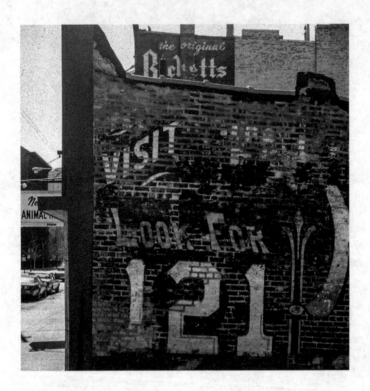

BUCKEYE. A brand of men's work clothes, proudly boasting, "Union Made." With the decline of unions in the United States, one rarely sees this designation anymore. The makers clearly considered it a good selling point.

YONDORF BROTHERS. A clothing outfitter for men and boys.

TOP Close-up Misfit Clothing Ad, 1994, before 1910, 1024 North Clark. Lost.

OPPOSITE, TOP Buckeye Union Made, 1988, 1920s, 1900 block West Chicago.

OPPOSITE, BOTTOM Yondorf Bros., Men's and Boy's Outfitters. 1985, 1930's, northeast corner, North and Halsted. Lost.

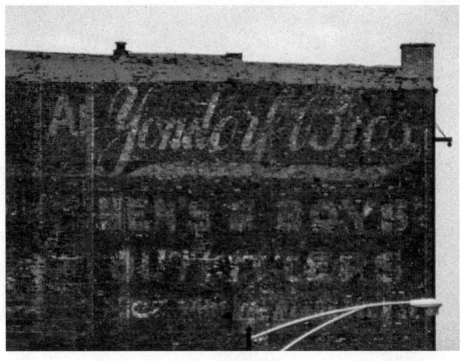

TOBACCO

TOBACCO. An unusually lettered fading ad, not so faded when I first discovered it, advertises, "Tobacco, the Old Standard." Although the name of the product is missing, I saw no evidence of part of the ad being obscured, other than the recent small billboard. A clue to the name is found on page 90 of Frank Jump's *Fading Ads of New York City* in an ad for Mecca cigarettes. It dates from the era when cigarettes often had exotic names from the Near East, and the lettering style in the New York ad so closely matches this ad that I doubt it is coincidental.

TOP Tobacco, the Old Standard, 2005, 1910s, Clark and Roscoe. Lost.

BOTTOM Close-up of tobacco ad, 2005, 1910s, Clark and Roscoe. Lost.

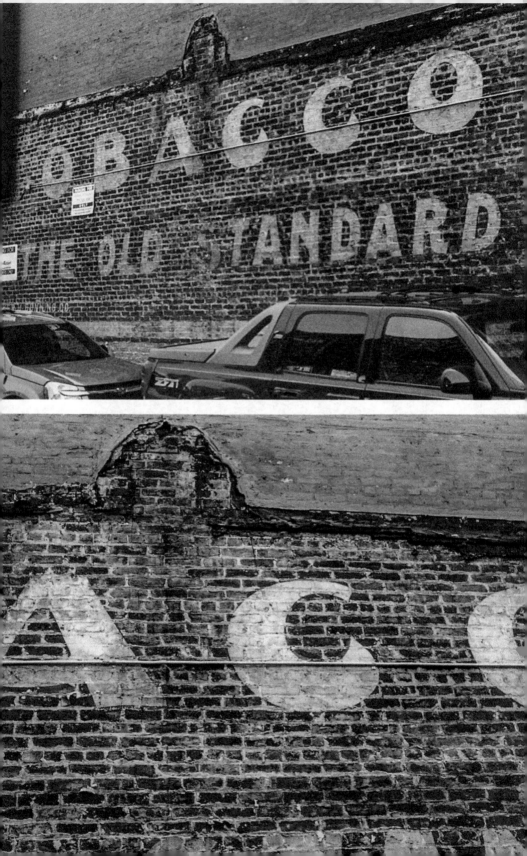

TOPAZ. While no wording other than "Topaz" appears, I am confident this was a brand of cigarettes. A Google search of extensive lists of early tobacco brands does not yield it, but Topaz has the exotic name of a jewel. Other early brand names of this type include Ramses, Sultan, Nazir, Salome and Pasha. One brand that is still on the market in America and overseas carries this type of name: Camel.

OPPOSITE Topaz, 1998, 1910s, Noble and Erie. Trace remaining.

FOR THE HOUSE

ROYAL VACUUM CLEANER. The Royal Appliance
Manufacturing Company had its start in Cleveland, Ohio, in
1905. Its story is not dissimilar from that of other inventions
of the early twentieth century, such as the airplane or early
automobiles. The originator of this invention was one man
in his Cleveland garage. P.A. Grier started what is one of the
oldest vacuum cleaner companies still in operation. It makes
a variety of cleaners for the home and for industrial use and
was the first to make a hand-held vacuum. Apparently, Royal
is not a giant like Hoover but does still sell its products in its
own stores.

OPPOSITE Royal Vacuum Cleaners, 1992, 1970s, 600 block
North Dearborn. Lost.

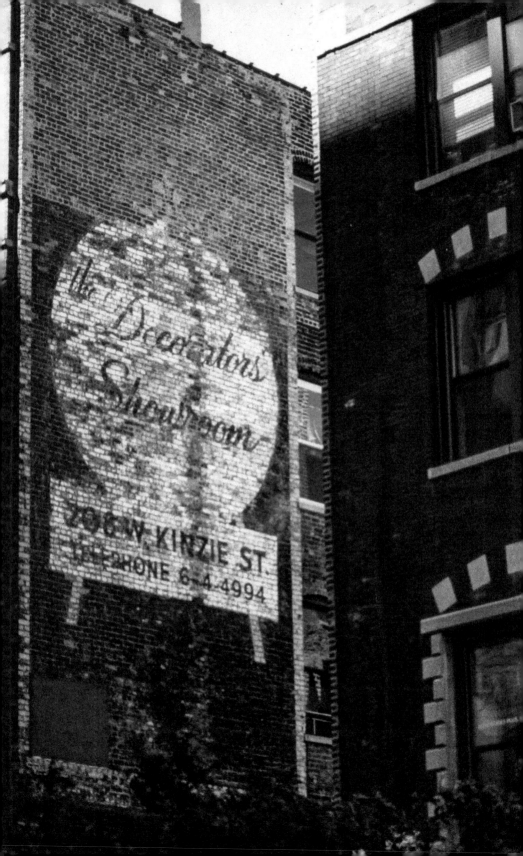

THE DECORATORS SHOWROOM. This type of business was generally not open to the public but was for interior decorators to get ideas and buy or order home furnishings for their clients.

OPPOSITE The Decorators Showroom, 1997, 1960s, 208 West Kinzie.

BANKS

BOWMANVILLE NATIONAL BANK. This ad on the side of a large brick building is one of three on the same wall. Bowmanville is a residential area in the Lincoln Square community area in the mid-North Side. The bank opened in 1912 at the intersection of Lincoln, Western and Lawrence Avenues. Until 1921, it printed money for the U.S. government. Later, it moved to a handsome limestone building. A picture of the full ad appears in the Introduction. Included here is a close-up of the circle in the lower left corner indicating "1st." First in what, we might ask. We may never know. The bank is hardly alone in a little braggadocio.

OPPOSITE 1st, Bowmanville National Bank close-up, 2009, 1920s, 6300 block North Western. Present.

STATE BANK. Although one supposes that any bank would identify itself, the identity of this one is not visible. I could not resist including the adjoining billboard for a 1990 movie with Steven Segal, *Marked for Death.* Indeed, many state banks were marked for death in the Depression.

TRUST AND SAVINGS BANK. This ad is just north of the Chicago city limits in Evanston.

TOP State Bank, 1989, 1920s, Lincoln and Ashland.

BOTTOM Trust and Savings Bank, A State Bank, Capital 100,000, 1984, 1920s, Evanston, Illinois.

VARIOUS BUSINESSES

APIX BATTERIES. This looks like a late 1930s or early post–World War II ad showing a uniformed service station attendant in the era before self service. It was on the side of an auto repair garage. The batteries had all the qualities you would want.

TOP Apix Batteries, Faster Starting, Longer Lasting, 2004, 1930s, Irving Park west of Kedzie. Lost.

BOTTOM Apix close-up, 2004, 1930s, Irving Park west of Kedzie. Lost.

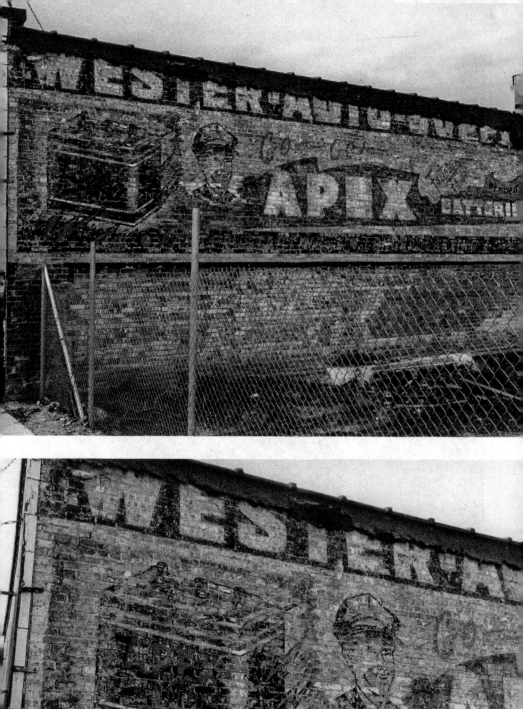

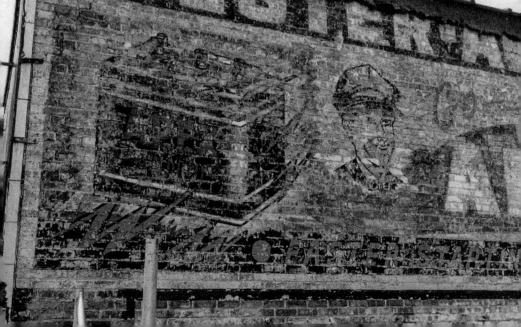

LILL COAL COMPANY. This ad appears on the same massive wall as the Sommerville National Bank ad. Lill Coal and Oil Company began as a brewery in Chicago around the time the city was incorporated. Thirty-eight years later, a fire destroyed the brewery, but the horses and wagons were saved. The enterprising owners then began hauling bricks, ice, coal and, in 1947, fuel oil. The Lill family sold the business in the mid-1970s. I remember seeing its massive coal trucks. No coal companies operate in Chicago today because coal furnaces can no longer be used in the city, and Lill is not listed among fuel oil dealers.

OPPOSITE Lill Coal, Dependable Coal, Prompt Delivery, 2009. 1920s, 6300 block North Western. Present.

MOTOR HOTEL. This ad is the most recent I photographed, in 2018, and probably dates to the 1930s. The term "motel" is, of course, an elision of "motor hotel." The contraction began being used after World War II. Hotel doors opened on interior hallways. Motel doors opened on exterior walkways or directly adjoined the parking lot. The first motor hotel opened in California in 1925, the Milestone Mo-tel in San Luis Obispo. The term "motor hotel" was first used in the 1920s.

NORTH SHORE PROPERTY. This ad was found on the mid-North Side. As Chicagoans know, it does not refer to lakeside property on the North Side of Chicago. Rather, "North Shore" refers to the suburbs north of Chicago along Lake Michigan. The ad lists the various services the company provided. It seems aimed at helping people who were contemplating moving up in the world to know where to go for help in achieving their dreams.

OPPOSITE Motor Hotel, 2018, 1930s, 1600 block West Belmont. Present.

ABOVE North Shore Property, Money to Loan, Renting, Insurance, 1984, 1920s, Broadway and Barry. Lost.

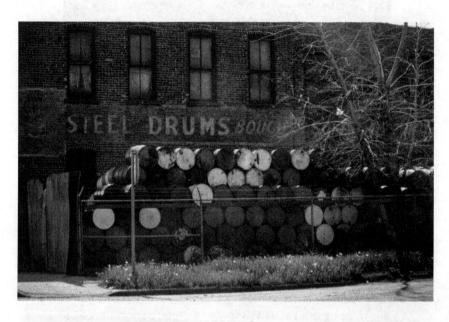

STEEL DRUMS BOUGHT. Many types of products have been recycled long before the term "recycling" entered our everyday lives. Barrels and drums are one type, along with car parts and junk.

STRONGHOLD SCREW PRODUCTS. Information from the internet indicates that this company name was in use prior to 1954. At that time, another company sued Stronghold for patent infringement for use of the name "Stronghold." The plaintiffs won, and Stronghold Screw Products became Strong Screw and Bolt.

TOP Steel Drums Bought, 1981, 1950s, Hubbard and Leavitt. Lost.

BOTTOM Stronghold Screw Products, 1997, 1950s, Hubbard and Franklin.

ZECHMAN LUMBER. Chicago has never had a shortage of lumber companies. Early in Chicago's history, most houses and many commercial building were wooden. The Chicago fire of 1871 gave city fathers reason to enact new building codes. This company now sells mostly to contractors.

CREOLE. This ad probably once included additional information. This may have been part of the name of a food product.

TOP Zechman Lumber, 1998, 1930s, Damen and Chicago.

BOTTOM Creole, 2001, 1910s, about 1500s Milwaukee.

FADING ADS NOT ON BRICK WALLS

A ds that are found on surfaces other than brick walls suffer the same fate as ads on brick walls, with one exception. They do not become "ghost signs" because the lead paint does not get absorbed and leach out, giving that ghostly look. Fading ads can be found on any surface capable of holding paint, such as stone, metal or wood. Two ads in this section were painted on water tanks. Water tanks such as these have largely disappeared from Chicago. They are part of an antiquated firefighting system.

THE SULTAN OF SULU. What we have here is not a painted ad at all. It is a poster. Imagine finding a paper poster for a 1903–4 musical performance in Chicago intact eighty-five years later. There it was, in the Loop, visible while the building to the north was being demolished. I have included it here because it is so unusual. The production, described as a Philippine musical, was based on a two-act satire by well-known writer, newspaper columnist and playwright of the day, George Ade. He was born in Lafayette, Indiana, graduated from Purdue University and was an associate of the famous cartoonist for the *Tribune*, John T. McCutcheon. Ade wrote humorous columns illustrating local life.

GREAT NORTHERN, SHORE ACRES. This poster was immediately to the west of *The Sultan of Sulu* ad. The Great Northern was a theater in the Loop where the musical was most likely playing. Shore Acres refers to Indiana real estate. Since this appears to be one poster, it's a bit confusing.

TOP *Sultan of Sulu*, 1989, 1903 paper poster, Wabash and Madison. New building on site.

BOTTOM Great Northern. Shore Acres, 1989, 1903, Wabash and Madison. New building on site.

SCHLITZ BAS RELIEF. These half-globe bas reliefs were found on "tied" taverns that sold only Schlitz.

TRAIN STATION. This ad was on the 63rd and Dorchester stop for the Green Line L (elevated train), which had originally extended to Stony Island Avenue. Passengers had once exited there to attend the 1893 Columbian Exposition. When this picture was taken, the Dorchester stop was the end of the line. Later, in stages, the line was shortened to stop a few blocks west at Cottage Grove Avenue, the end of the line today. Some wish it still extended to Stony Island because very near the old end of the line is where the Obama Presidential Center is to be built.

SOO LINE. The Minneapolis, St. Paul and Sault Ste. Marie Railroad was founded in 1883 to haul grain from Minnesota to eastern markets. One of the founders was Charles P. Pillsbury. Pillsbury products are still sold today. The railroad carried lumber and iron ore and had passenger routes, which declined when rail travel declined across the country. The Soo Line last existed as a private company in 1990. This ad is the first of three on railroad bridges.

TOP Schlitz, 1980, 1920s, northwest corner 21st and Rockwell. Lost.

MIDDLE Train station, 1983, 1930s, 63rd and Dorchester. Terminal taken down.

BOTTOM Freight, Soo Line, terminal, 1981, 1950s, on railroad overpass 15th and Canal. Lost.

PULLMAN TO ST. LOUIS. Like many of us, I used to take train trips with my family, but we went by coach because travel by Pullman was a luxury most Americans could not afford. George Pullman started his company in 1862, and for most of its life, his factory was located in the Pullman community area of Chicago. His workers lived in Pullman. They went on the famous and deadly strike of 1894. Sleeping cars were his hallmark, although he built other luxurious cars for fine dining, game rooms, smoking rooms and libraries. These cars operated on multiple railroads and carried his name until the 1980s. They frequently show up in old movies. The last sleeping car was built in 1956, and the Chicago factory closed in the mid-1950s, but the company made streetcars and trolley buses in other locations until 1982. The Chicago workers' homes still stand and are well maintained. Pullman's hotel and part of the remains of the factory are being restored and are designated as a National Historic District. Parts of the area containing employee housing and other structures also are designated as a Chicago Landmark District. The area has also earned State of Illinois recognition. It is famous for being one of the first planned industrial communities in the country. Other famous names associated with the Pullman Company are Robert Todd Lincoln, who lived in Chicago and became president of Pullman in 1897, and A. Philip Randolph, who became president of the influential porters' union. A museum in the area is named for him.

SHORT ROUTE TO ST. LOUIS. This ad is on the opposite side of the railroad overpass showing the Pullman ad.

TOP Through Pullman to St. Louis, GM&O, 1980, 1950s, on railroad overpass 15th and Canal opposite Soo Line ad. Lost.

BOTTOM Short Route to St. Louis, 1980, 1950s, on railroad overpass about 3000 S. Damen.

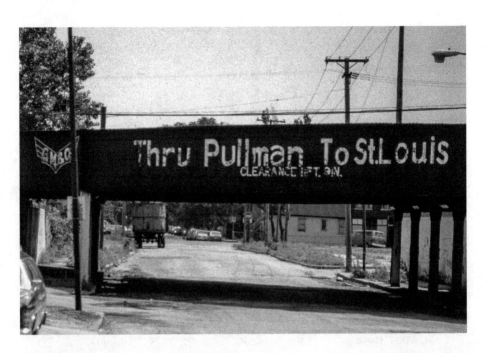

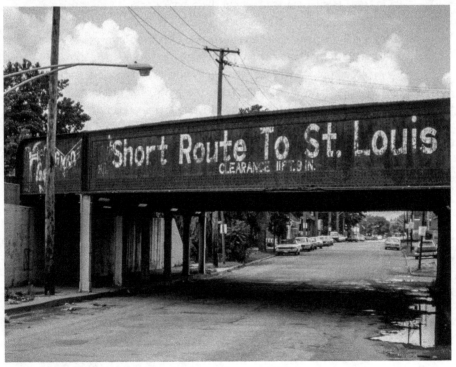

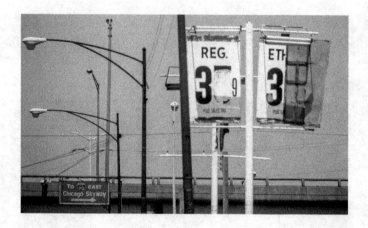

GAS 37.9. I found this forlorn ad dangling at a closed filling station. Whether this was the station's usual price or a gas war had forced down prices, I do not know. Gas wars were wonderful events for the customer, when several gas stations in an area duked it out to undercut the others' prices.

SAAB. This ad advertises the Saab automobile, an innovative Swedish auto that was introduced in 1949. Originally made by an airplane company, Saabs were small and aerodynamic and had three-cylinder engines that required that oil be put in its gas tank. Soon it had front-wheel drive and was ahead of its time with safety features. These cars were relatively popular in university areas. Below the water tank on one side of a brick wall is an ad showing a Saab car and indicating it got thirty miles per gallon. On another side of the wall is an ad for an MG, a popular sports car of the day.

ABOVE Gas 37 cents Gal, 1980, 1960s, sign at abandoned gas station about 64th and State. Lost.

OPPOSITE Saab, MG, Economy, 30 MPG, 1980. 1960s, on water tank about 25th and Michigan. Lost.

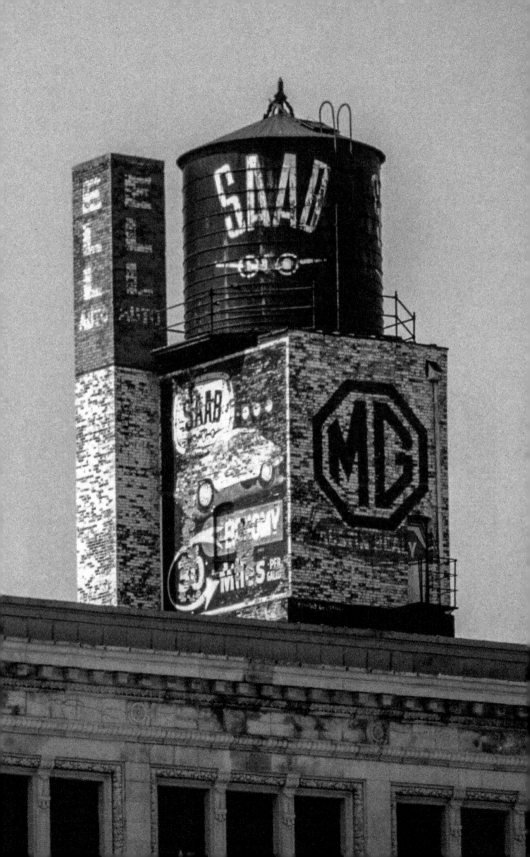

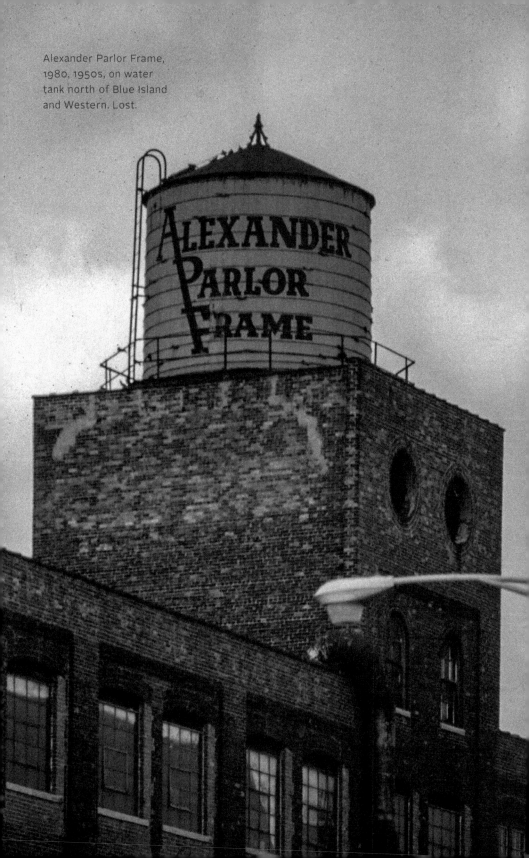

Alexander Parlor Frame, 1980. 1950s, on water tank north of Blue Island and Western. Lost.

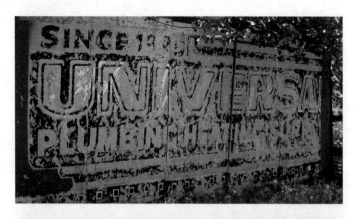

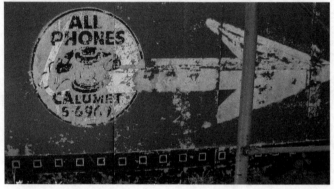

ALEXANDER PARLOR FRAME. The name indicates this company made the wooden frames for davenports and couches that sat in parlors. This emblazoned water tower probably sat on top of the factory. Any furniture-making shop, with its shavings and sawdust, surely needed fire protection.

UNIVERSAL PLUMBING. What you see are two parts of a long wooden ad at ground level. The whole ad is about one hundred feet in length. It was in very bad shape when I took the picture and since then either fell or was taken down.

TOP Universal Plumbing, 2015, 1950s, section of ad on wooden fence near 18th and State. Lost.

BOTTOM Universal Plumbing. 2015, 1950s, another section of fence. Lost.

6

FINAL THOUGHTS

Almost all of the advertisements pictured in this book were originally intended only for short-term relevance. Wall ads in some ways belong to the world of ephemera, along with newspapers, magazines and now, arguably, digital data. Newspapers come out daily; magazines may be published monthly or quarterly; radio and television ads last thirty seconds and are repeated for short durations; and in the Information Age, digital ads appear on our monitors with enormous regularity. We get phone calls for myriad products and services, offered by actual humans or robotic callers. For some ads, we use our eyes, others our ears, and often both. I suspect most of my mailman's daily deliveries are ads for which no one asked, which one hopes get into recycling bins. We are inundated by advertising. I'll bet one of the things you enjoy about vacations is that you can free yourself from advertising, if not entirely. Many ads are intrusive, and some are loud. I am not opposed to ads. This book would not exist without them. But have we become oversaturated?

Fading ads, even when new and unfaded, were primarily designed to inform in a quiet way. They offer the name of a product or company, may extol its benefits and may identify where to find it or call to order it. Although downtown areas tended to higher concentrations of wall ads than outlying areas, by contrast many current publications are all but consumed by endless pages of advertising. Certainly, there were aggressive advertisers in bygone years, pushy salesmen and hawkers of all sorts of merchandise, but the wall ad was a relatively quiet and passive form of advertising. It was just there.

Wall ads were meant to last a while, but one suspects no one putting them up thought they would still exist fifty, seventy-five or one hundred years later to tell onlookers about products mostly no longer made or needed. Anyone willing to make the effort can find old ads in newspapers and magazines in library archives. Fading ads, on the other hand, are still in front of us as we walk and drive around our towns and cities. They can be a part of the daily fabric of our lives. That raises the question of what we should do about those that remain in good enough condition to merit our attention.

In some communities, interested parties have been involved in repainting fading ads to replicate what was there as faithfully as they can. The results can be impressive if the effort was well done, but by then, of course, we no longer have the original ad. Other aficionados have photographed fading ads and assembled them in books such as the one you hold in your hands, and all those with which I am familiar are listed in the bibliographical notes. Dr. Ken Jones has turned his passion for photographing fading ads into an art form, and Frank Jump has shown his photos at the New-York Historical Society. Many images of fading ads in America and Europe are posted online. It seems that the best we can do now to preserve this small part of Americana is to take pictures and make them available in whatever way we can. I hope this book is a small contribution to this effort.

BIBLIOGRAPHICAL NOTES

THE INTERNET

Finding information about fading ads is a hit-or-miss affair. The internet was my primary source of information. Several categories of sites are worth exploring.

WIKIPEDIA. This source is productive for both old companies still in business and major companies of the past. I used Wikipedia for every picture in the book, except those extremely unlikely to be listed. Many entries provide a wealth of information. They often offer much more information than is relevant on such matters as corporate structural changes, ownership changes and the like. I extracted what was needed to put old ads in the context of the company's history and products, the founders and their times. As noted, this source provided no information for many ads. If an ad was for a local or regional product, or a mom-and-pop store that may have gone out of business seventy-five years ago, one would not expect help from the internet. Occasionally, I would be surprised by finding, for example, an obituary notice with unusual historic detail on an owner of a business that closed long ago.

COMPANY OR CORPORATION WEBSITES. I Googled every company or corporation still in business whose product is pictured in this book. Their company websites usually focus on current products, current

administrative structure and how to contact the company, with little on early history, product changes and development or advertising.

OTHER PRODUCT-RELATED WEBSITES. These sites generally provided little usable information. For example, many beer cans are collectible, so a beer company site might contain mostly ads for old beer cans for sale. Only occasionally might one find a bit of useful information.

NICOLE DONOHUE'S WEBSITE GHOST SIGNS: TRACES OF CHICAGO'S HISTORY. This site has a large number of ads photographed about twenty years ago throughout Chicago, predominantly on the North Side. There is virtually no overlap with the contents of my book, as most of my pictures were taken one or two decades before her work.

GOOGLING "CHICAGO GHOST SIGNS" generates links to many sites, one of which displays hundreds of pictures, mostly of Chicago fading ads. I suspect they were photographed in the last few years, judging by the fact that many show the effect of a long period of weathering. A few photos on this site appear in this book, although the site pictures were probably taken later. This site also has ads from other cities and non-painted signs. It is interesting to wander through it.

FORGOTTEN CHICAGO. This is the website of an organization that pictures and describes many facets of Chicago's past: buildings, ads, events, politics and whatever strikes the moderators' fancy. Content is added and subtracted from time to time.

DR. KEN JONES. Ken Jones has several websites, and others about him and his activities are also worthwhile. He has a massive archive of fading ads. Per information gathered from these sites, since 2009, he has photographed over seven thousand fading ads in four thousand cities in forty-eight states. He indicates that he has taken half a million photos, including many requiring advanced photographic techniques and equipment. He is highly trained technically and has worked at NASA and in visual effects for the motion picture industry. He processes his own work to produce sizeable enlargements, which are shown in art galleries. I looked through many sites devoted to his work but found few ads from Chicago.

BOOKS

A smattering of books on fading ads has been published in the last quarter century. This book is the sixth published by The History Press. The other five are:

Fading Ads of Birmingham, by Charles Buchanan, 2012.
Fading Ads of Cincinnati, by Ronny Salerno, 2015.
Fading Ads of New York City, by Frank Jump, 2011.
Fading Ads of Philadelphia, by Lawrence O'Toole III, 2013.
Fading Ads of St. Louis, by William Stage, 2013.

Frank Jump has been very active in this field for a quarter of a century, created the New York City Fading Ad Campaign and has had some of his pictures exhibited, including a show at the New-York Historical Society a few years ago.

William Stage authored two books preceding his book on St. Louis: *Ghost Signs: Brick Wall Signs in America* (ST Publications Inc, 1989) and *The Painted Ad: A Postcard Book of Vintage Brickwall Signs* (Floppinfish Publishing Company, 2011).

One last book on the subject, which includes a chapter on "wall dogs," is *Ghost Signs of Arkansas*, by Cynthia Lee Haas, photographs by Jeff Holder (University of Arkansas Press, 1999).

OTHER SOURCES

The Encyclopedia of Chicago, edited by James Robinson, Ann Durkin Keating and Jamie L. Rieff (University of Chicago Press, 2004). A small number of companies whose wall ads appear in this book are among the many entries in this book on major Chicago businesses. These entries are similar to what is contained on Wikipedia.

Illinois Secretary of State: Certified List of Domestic and Foreign Corporations, 1924 and following years. I sampled a few volumes of this series, at a few years' interval. This publication does not list small corporations and in any case (amazing for our age) lists the names and home addresses of their major officers. It was of virtually no help for this volume.

INDEX

Transportation and Transportation-Related

Undertakers

ABOUT THE AUTHOR

Joseph Marlin is a retired clinical social worker and administrator of hospital social work programs. But he's also a collector. This book is a selection from his collection of fading ad photos. For three decades or more, he has collected vintage cameras, especially examples from the Chicago photographic industry, including still, movie and street cameras. He collects art deco items and is a member of the Chicago Art Deco Society. He is a board member of the Hyde Park (Chicago) Historical Society and on the board of a local effort to maintain affordable housing. Since he likes old things, he has lived in his 115-year-old semi-attached row house for fifty years. If you find some readable fading ads not in this book you can let him know at josmarlin@sbcglobal.com.